# HAVE A LOFF!

## HUMOROUS PHOTOGRAPHS OF THE BLACK COUNTRY

## GRAHAM GOUGH

AMBERLEY

First published 2022

Amberley Publishing
The Hill, Stroud
Gloucestershire, GL5 4EP

www.amberley-books.com

Copyright © Graham Gough, 2022

The right of Graham Gough to be identified as
the Author of this work has been asserted in
accordance with the Copyrights, Designs and
Patents Act 1988.

ISBN 978 1 3981 0997 1 (print)
ISBN 978 1 3981 0998 8 (ebook)

British Library Cataloguing in Publication Data.
A catalogue record for this book is available from
the British Library.

Typesetting by SJmagic DESIGN SERVICES, India.
Printed in the UK.

# FOREWORD

I was fortunate enough to gain my first job in press photography/photojournalism at the *Dudley Herald* series of publications in the 1960s. The senior photographer was Graham Gough, and his passion and love for photography was infectious, plus his incredible love and respect for the area we worked in was clear to see in his images. He has the skill of getting the best out of the subject, whether that be people, animals or landscapes. One of Graham's great loves apart from his wife and family, is the Black Country'. This publication, I am sure, will raise a laugh – oops, 'lof'.

During the early days he covered the royal visits of her Majesty the Queen and Princess Margaret; the funeral of footballer Duncan Edwards, who died in the Munich air disaster; but the biggest news story of them all was the Dudley Riots in August 1962.

In 1966 he left Dudley and moved to Devon to join Daily Mirror Group in the South West. During his time in the West Country he covered a wide range of assignments, from films and TV stars to the *Pacific Glory* oil tanker disaster, the Royal Review of the home fleet and spending time on HMS *Eagle* and going aboard the Royal Yacht *Britannia*.

Then in the late 1970s he returned to his home ground and joined the Express & Star in the West Midlands. During his time there he won the Midland News Picture of the Year Award in 1975 and 1976. The picture in 1975 of male stripper Andy Wade was published worldwide and artist Beryl Cook based her painting *Ladies Night* on his photograph. In the Queen's Silver Jubilee in 1977 he won the National Royal Picture of the Year Award and in 1983 he won the Midlands Press Photographer of the Year Special Award and the Best Balanced Picture in the same competition in 1993.

In 2000 he left the Express & Star and concentrated mainly on landscape photography for the tourist industry and to promote Britain at home and abroad. His photographs are used to illustrate books and magazines. Graham started in 1954 with a 5×4 glass plate press camera and now uses the latest digital press camera. I am sure you will agree with me that a picture is worth a thousand words.

Paul Delmar
Retired Head of the National Council for the Training of Journalists
Press Photography/Photojournalism National Course

# FUNNY SIDE OF THE CAMERA

One of the most difficult things I've found over the years is capturing instant humour, and when it does happen you have to be quick and ready and that's not always possible.

So its not surprising that photographers like myself set up humorous shots or run with the funny side of some of the news stories we come across. Once you have an idea and the picture is set up what you then need is spontaneity to make it seem that you have just stumbled upon it. There is little trickery involved – well only occasionally – just a little imagination and some thought beforehand and a degree of trust between you and the subject.

Children love to do funny things and are less self-conscious than adults in set-up situations. But animals can upstage every time ... as the chimp in the gents proves.

All images are by Graham Gough.

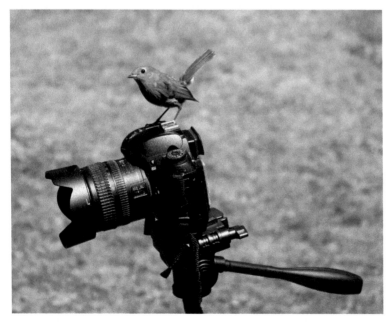

Watch the birdie.

# LOFF IT OFF
## Animals

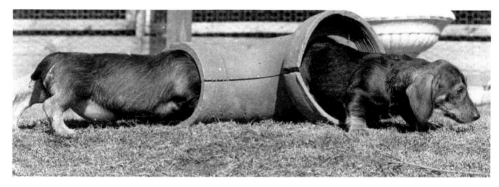

*Above*: Shaggy Dog Story Two dachshunds playing in a pipe appear to be one dog.

*Right*: Hot Dog Tara the Great Dane gets a little worried when she nears the hot dog stand at the Dudley Show.

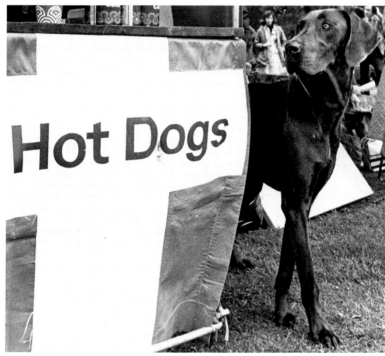

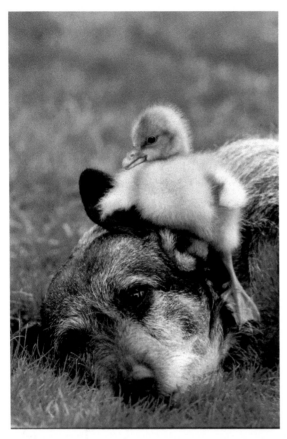

*Left*: Its That Duck Again
Oswald the gosling made friends with Tasha the pet dog of Mike Williams from Himley, but Tasha got a little fed up with the attention and put on this air of indifference.

*Below*: Double Act
It's a double act when these two St Bernards join the competition at the Dudley Show.

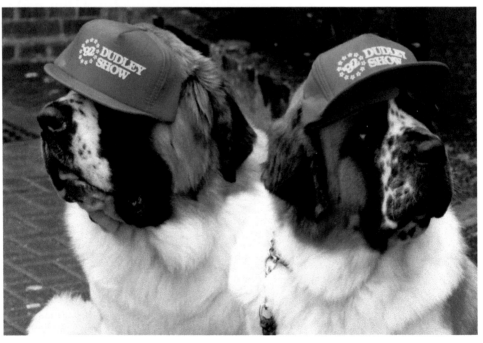

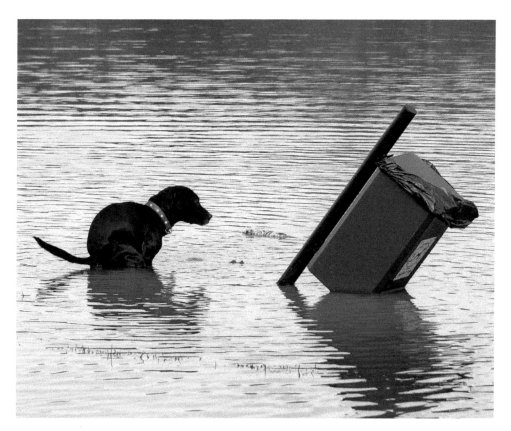

*Above*: So Near yet So Far
A dog takes a pee on flooded ground
in Stourbridge as near as he can get to
a litter bin.

*Right*: Couch Pooches
That's one way of keeping the dogs
quiet at boarding kennels in Himley.

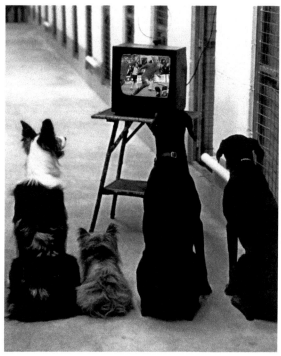

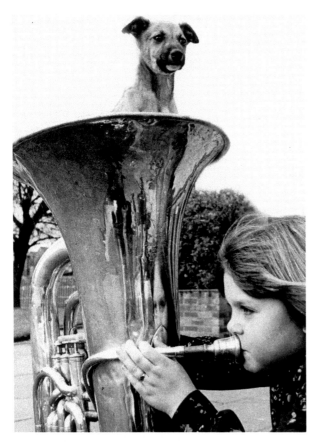

*Left*: Getting the Wind Up
It's a bit windy up here! Karen Bradford puts the wind up the puppy dog Maggie to publicise Dudley Spring Festival of brass bands and dog racing.

*Below*: Little and Large
Two unlikely pals at the Dudley Show in 1991: Nelson, the 120-lb Harlequin Great Dane; and 12-ounce Miniature Pinscher Torry.

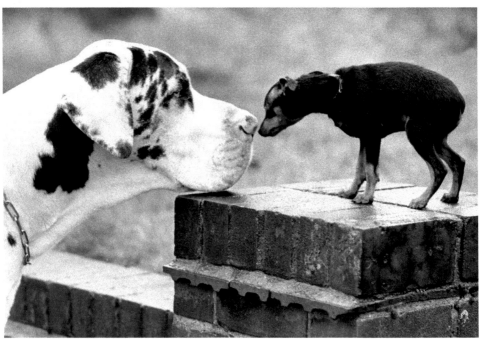

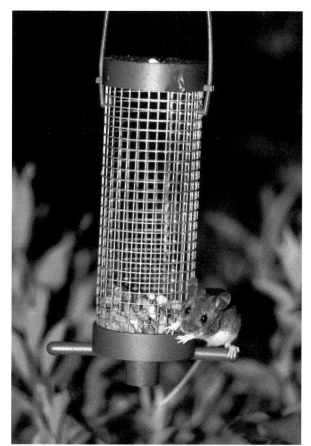

*Right*: Caught in the Act
A field mouse gets a surprise when I catch him raiding the bird nuts in my garden.

*Below*: Keep in Line My Prickly Friends
This puppy dog was a bit of a sergeant-major when he lined up these three orphaned hedgehogs.

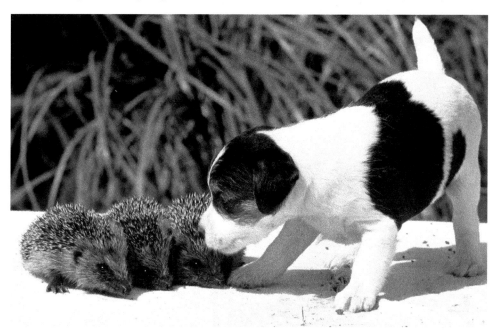

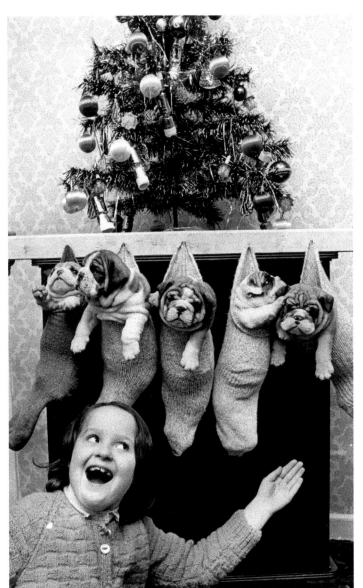

*Left*: Stocking Fillers
Jane Holloway from
Brierley Hill had five
lively stocking fillers
at Christmas in 1979.
Her dad, Richard, was
a bulldog breeder and
he let Jane keep one for
a present.

*Below*: In the Dog
House
Albert Cartwright
from Prestwood near
Stourbridge gets
his head down with
thirteen red setter
puppies. Their mum,
Trynka, had this
amazing amount of
puppies and Albert had
to sleep in the kitchen
with the pups to make
sure they all got a share
of mother's milk.

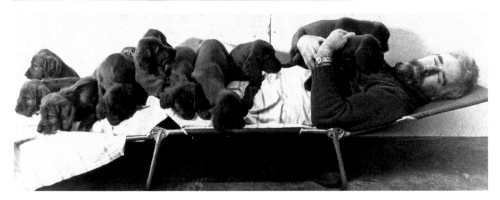

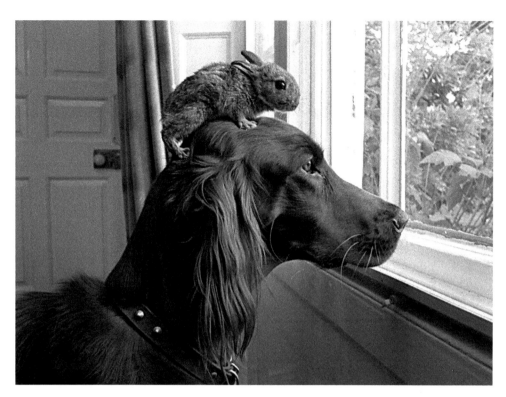

*Above*: Head for Heights
What's up dog? This tiny rabbit was rescued and made friends with Bamba the red setter its favourite spot was on the dog's head.

*Right*: Snarl Please
PC Terry Davies is teaching his new police dog recruit Zappa to snarl. It was the first day of training for this rottweiler at West Mercia Police Dog Training School.

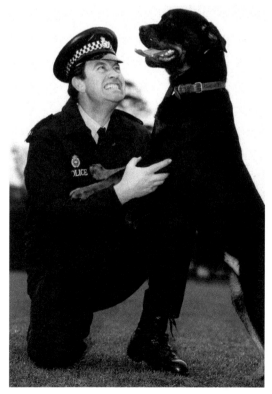

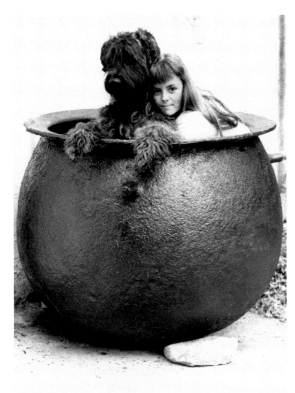

*Left*: Two for the Pot
This brewing pot looking very much like a witch's cauldron was used as a giant collecting box to raise money for Arley parish church near Kidderminster. Kerry Bestwick is pictured with her pet dog Chester inside the pot, which stood outside the Harbour Inn.

*Below*: You Looking at Me
This scary kitten made such a good picture as it popped its head through a curtain.

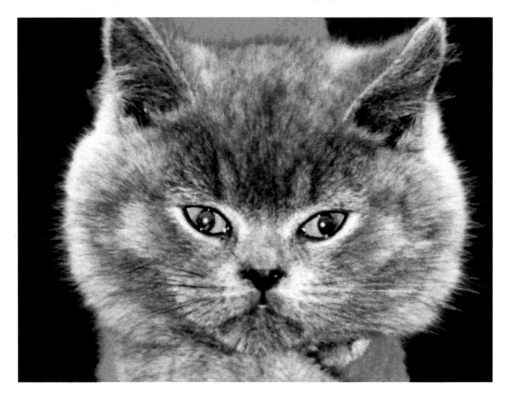

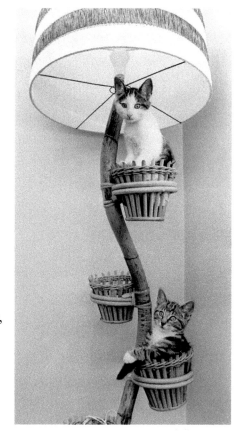

*Right*: Astrokits
These two lovely kittens, George and Miss Banks, pictured sitting in plant holders on a standard lamp, look as if they are ready for take-off!

*Below*: 'Give Us a Kiss
This donkey at Dudley Zoo Farm was keen to make friends with the farm cat Jess, but she was having none of it!

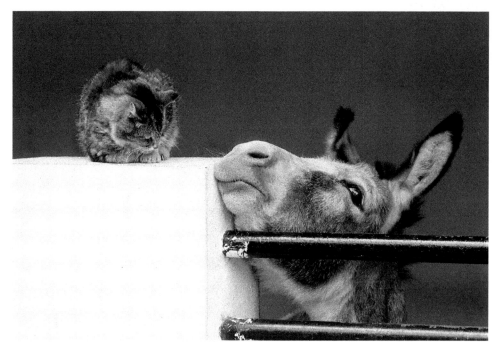

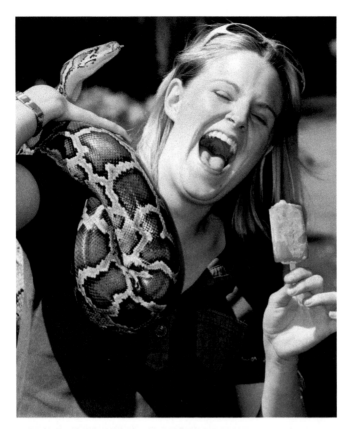

**A Monty Python**
This Indian python seems a little 'Monty' as it attempts to share a lollipop with this young lady at Dudley Zoo.

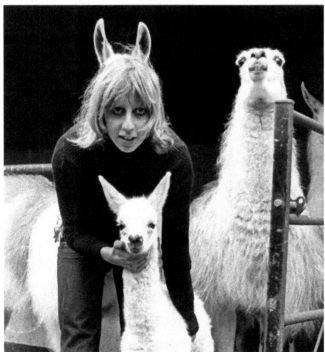

**Ear-Ie Picture**
Zookeeper Joanne Blount seems to have sprouted ears when she posed with Babs, a newly born llama at Dudley Zoo.

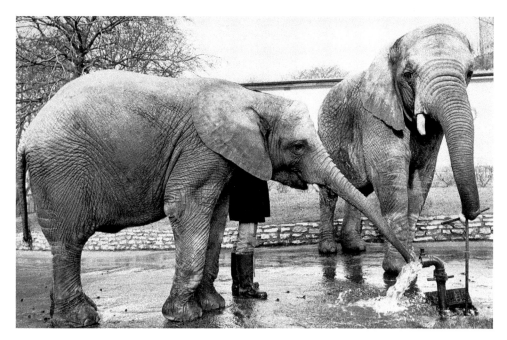

*Above*: Elephant Man
There appears to be a man operating one of the elephants from Dudley Zoo while they are drinking from standpipes during the water workers' dispute of 1983. (Award-winning picture)

*Right*: The End Is Nigh
Flossie the Dudley Zoo elephant got a little help from Nigel Summerfield when she became temporarily wedged in the archway of Dudley Castle.

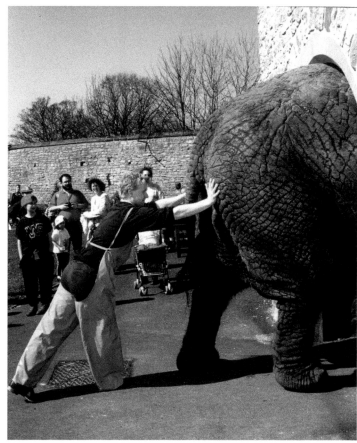

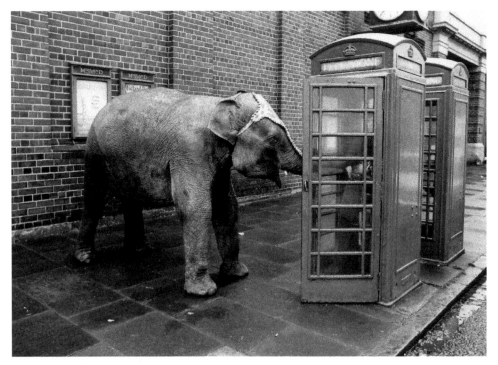

**Phony**
Suzy the circus elephant is a bit of a phony when making a trunk call at Dudley bus station.

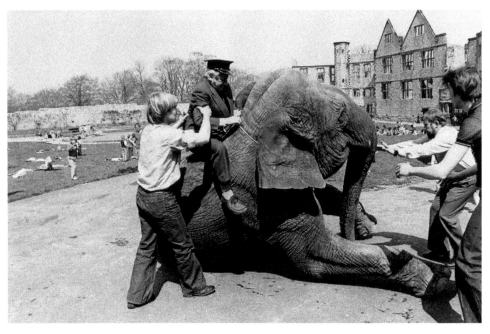

**Slip-sliding Away**
Johnny Morris, the famous BBC Children's TV presenter, had trouble getting onto the elephant when making a TV advert for Dudley Zoo.

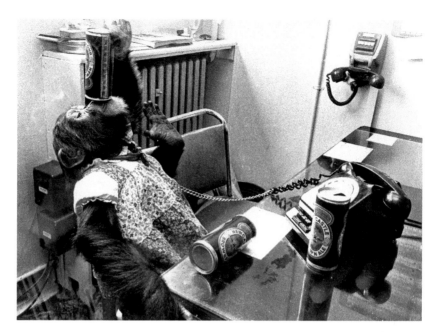

Canned
Its been recently discovered that chimpanzees in Guinea enjoy a drop of alcohol by drinking fermented palm sap – so it's not surprising that Koko made a beeline for the manager's booze on a visit to the Plaza cinema, Dudley, during a publicity photo call.

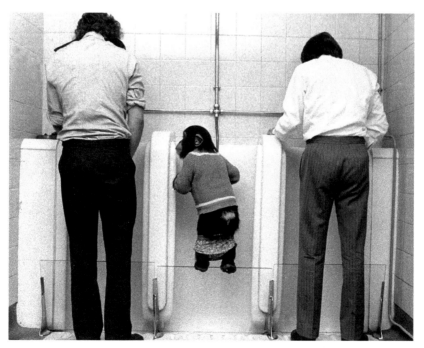

Chimpan-pee
No matter where the keeper went Koko the Dudley Zoo chimp was sure to go!

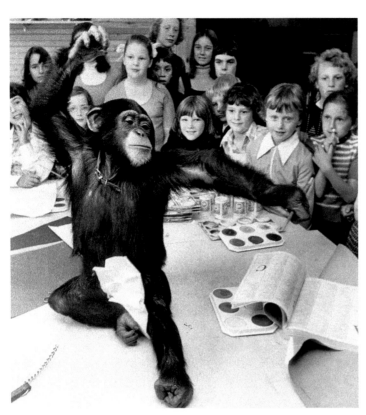

*Left*: Glamour Girl
This female chimp
set a perfect pose for
these young artists at
Leasowes Community
College, Halesowen.

*Below*: Smile Please
Mitzi the monkey gets
a dental check-up by
Black Country vet
Emil Stewart.

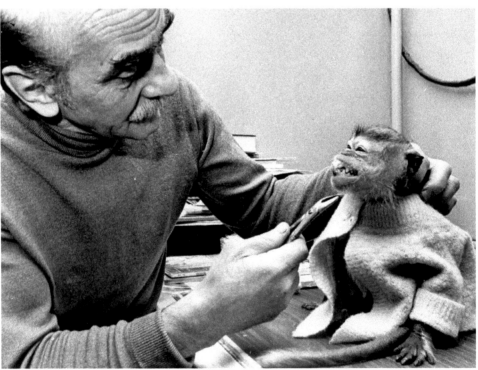

**Right**: You've Missed a Bit, Mate
Emma the lioness at Dudley Zoo keeps a close
eye on Tom Edwards as he gives her enclosure
a fresh coat of paint.

**Below**: Quiet in the Ranks There
Girls from the 1st Four Oak Rangers get
a morning inspection by Tim the tapir
before they become keepers for the day at
Dudley Zoo.

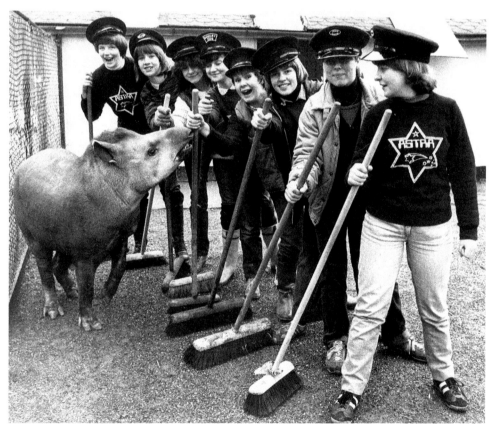

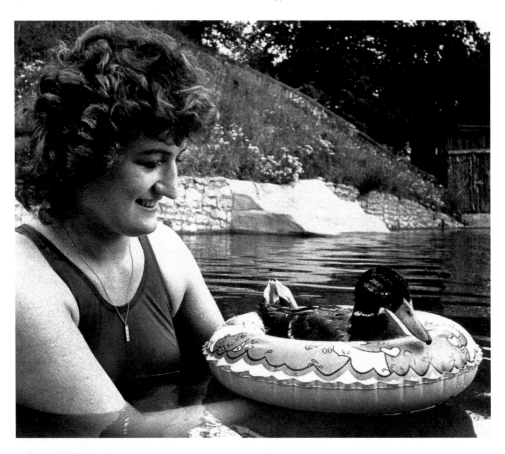

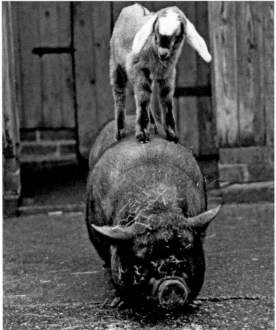

*Above*: Taking a Duck to Water
Alexander the duck having swimming lessons after spending a year on dry land. He was rescued by Alan Darby after being orphaned and kept at his home with his Labrador dog. He was given to Dudley Zoo, who discovered he couldn't keep afloat because his natural oils had gone during his year ashore. So Wendy Foster took on the task of teaching Alex to swim.

*Left*: Piggie Back
Why walk when you can ride. This goat at Cotwall End Local Nature Reserve, Sedgley, had a habit of taking a ride on his pal's back.

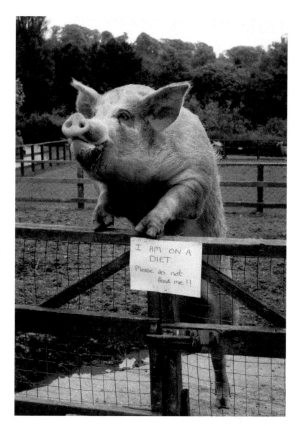

*Right*: Fat Lover
Percy the 20-stone pig at Cotwall End Local Nature Reserve had to be put on a diet. Visitors had been feeding him with sweets and cakes and he was becoming too heavy to do his duty and start a family.

*Below*: Suckers
Around the same time that Sarah Ferguson was caught with Texan millionaire John Bryan in the infamous toe-sucking picture I captured these two orangutans doing the same thing – but for some reason it didn't have the same impact!

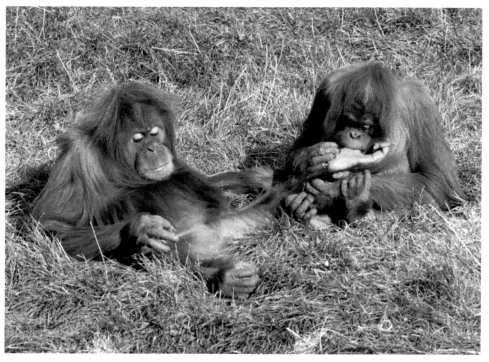

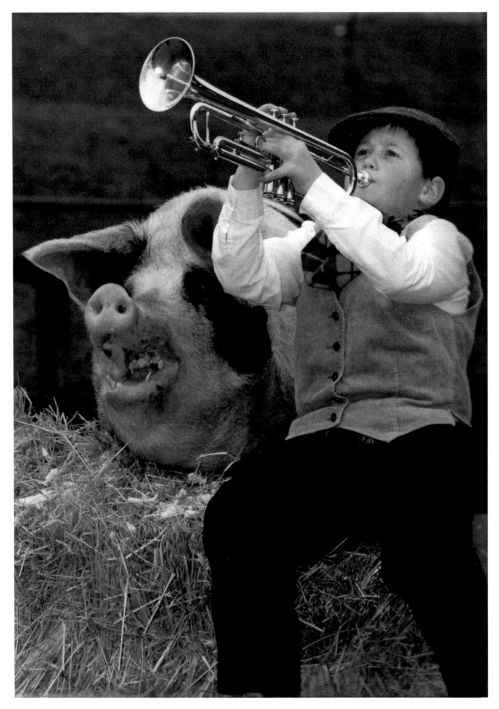

Pig and Trumpet
Jodie the Gloucester old spot pig was serenaded by nine-year-old trumpeter Ben Capewell at a
Black Country Christmas held at a Stourbridge school.

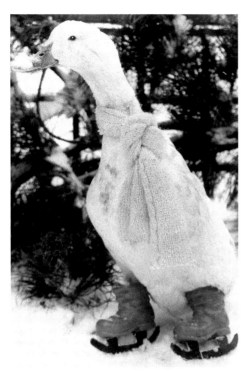

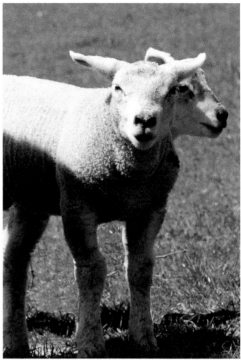

*Above left*: Quackers on Ice
You don't believe this do you? Well let me tell you that Pierrot was the first and only skating duck I had ever seen and she enjoyed fooling around at the Pets Hotel near Dudley with special skates made for her.

*Above right*: Two Heads Are Better than One
What dubious people you are! This two-headed lamb was seen in a field close to my home, and like you dear reader I couldn't believe it.

Musical Porker
Its the custom in Gornal to put the pig on the wall during Good Friday to watch the band go by. So this little pig was trotted out to dip his snout in the musical trough.

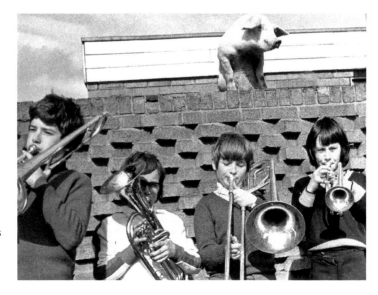

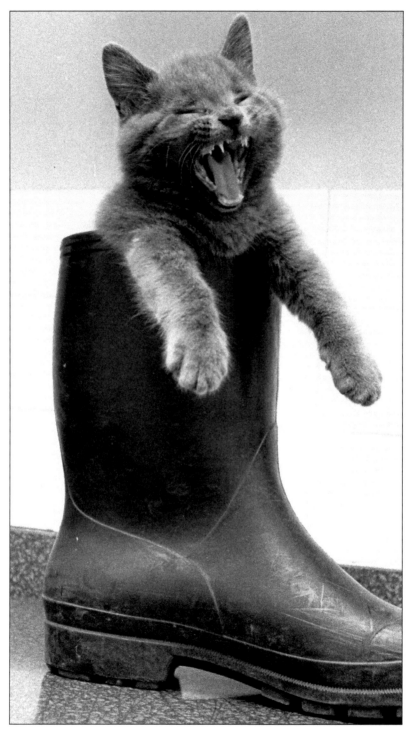

Puss in Boot
Smokey the kitten loved playing in wellington boots and sometimes got stuck in them ... but you have to laugh it off.

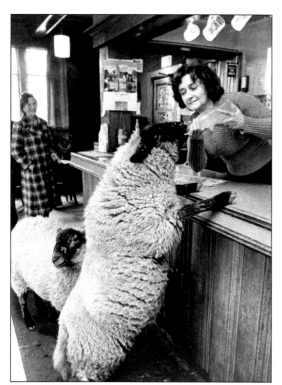

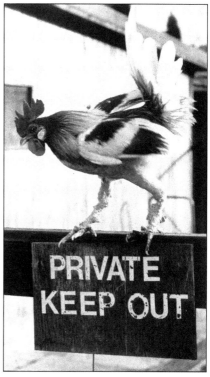

*Above left*: Sheep at the Barr
Sheepish customers at the Hillcrest pub were used to being asked if they were going down the milk barr – and mention mint sauce and landlady Margaret Valance was likely to give you the chop. Mark and Mindy were pets to Margaret and her husband Bill Valance who ran this Kingswinford pub.

*Above right*: Gregory Peck
Anyone planning fowl play at this farm in Sedgley had rooster Gregory to deal with.

*Right*: Seething Magpie
Maggie the orphaned magpie was taken in by kind a family in Kingswinford and she loved singing along to the radio, except when Terry Wogan was on. She took a dislike to Terry and would aggressively squawk when he was giving his banter.

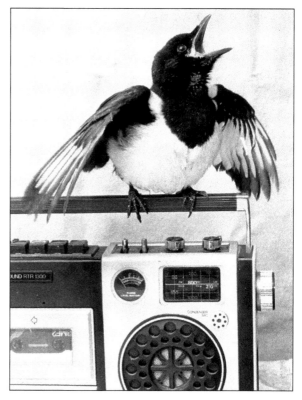

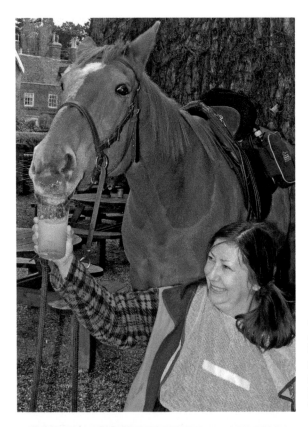

**Ale-ing Mare**
After a canter over the South Staffordshire countryside there is nothing like a pint of ale for Layla the mare. She shares her pint with her owner Sam Ashmead outside The Cat Inn at Enville.

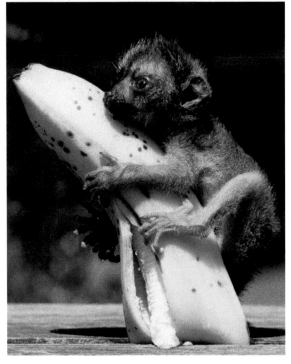

**Hanging onto His Lunch**
Matt the orphaned lemur at Dudley Zoo hangs onto his lunch after being rejected by his mother. But staff at the zoo hand-reared the monkey and a banana is obviously his favourite food.

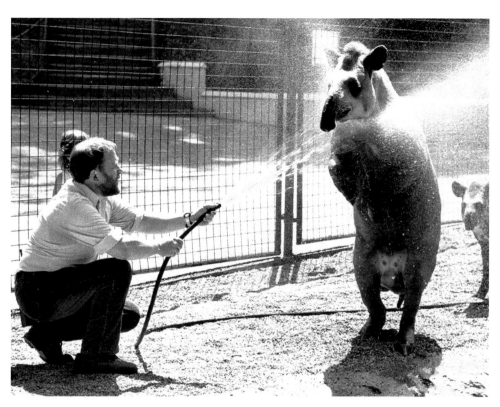

Tapie-ing Hot
Tim the tapie gets a cooling down during the summer of 1977 from Dudley Zoo's curator Chris Round.

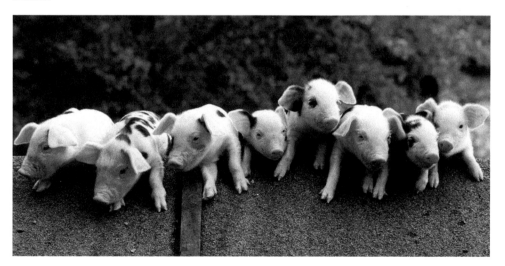

Spots Before Your Eyes
Eight Gloucester old spots all in a row looking over the farm wall.

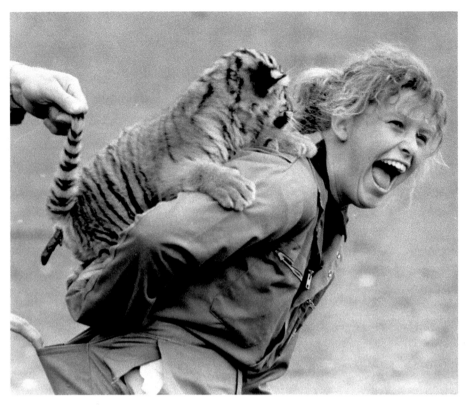

Dirty Trick
This is what your colleagues do when your back is turned.

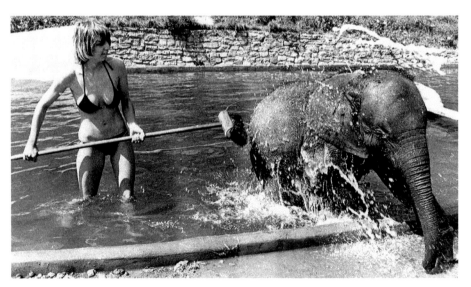

Wash and Brush Up
Dudley Zoo keeper Joanne Blount keeping baby elephant Estar cool during the hot summer of 1979.

# LOFF IT OFF
# Children

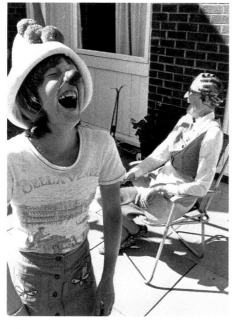

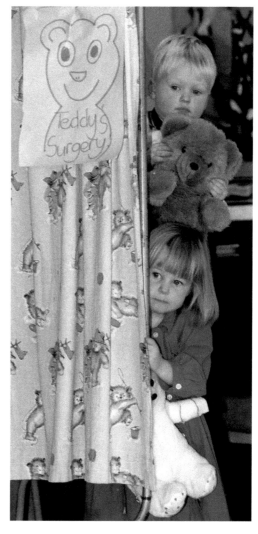

*Above*: Loff-in Granny
Giving granny a loff on Red Nose Day.

*Right*: Can't Bear It
Young visitors to Russells Hall Hospital were invited to bring their teddy bears for treatment during Play in Hospital Week in the children's ward. Sam Turner (three) and Bethany Lowe (two) nervously peeped into the Teddy's Clinic.

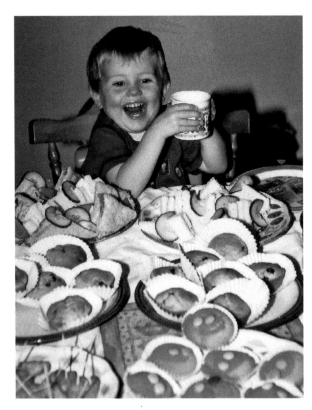

*Left*: Outbreak of Cake
This young lad seems to have his cake and eat it, and is in party mood.

*Below*: Gobsmacked
This young lad gets a mouthful of frankfurter during German Food Day at Dudley Market.

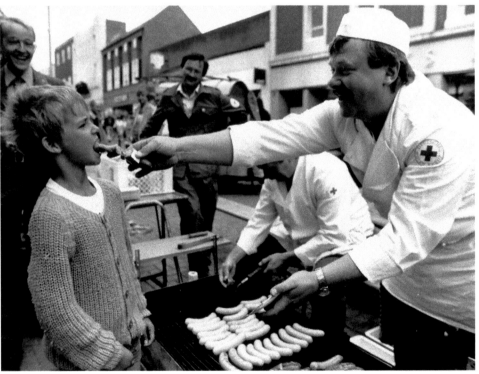

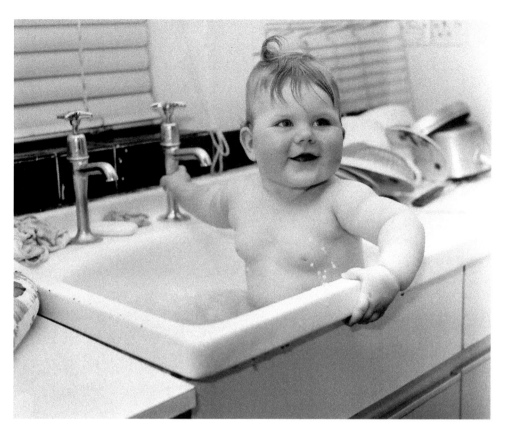

*Above*: A Bathe for Babe in the Sink
It was a hot summer in the Black Country, so to save water this young lady shared the sink with the washing-up water.

*Right*: Kiss Conscious
David Ride, seven months old, doesn't seem interested in the valentine kiss offered by four-year-old Maria Chapman.

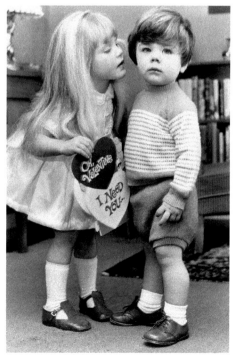

Party Hat
This Black Country lass is all ready to party with her cheeky hat.

*Above left*: These Boots Were Made for Walking
James Mander is ready for the Dudley Trail Sponsored Walk in aid of Action Heart at Himley Hall.

*Above right*: No Dummy at Darts
The amazing dart-throwing of eighteen-month-old Jarred Watkins of Sledmere, Dudley, got him onto TV … but he could never play without his dummy.

*Right*: I Just Can't Look
Four-year-old Alan Hilton was dragged along to his mum's keep fit class at Wordsley Community Centre, but was just too embarrassed to watch.

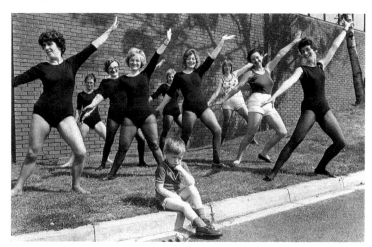

*Left*: Scary
Its that bloke again with the camera.
Let's all pull faces at him.

*Below*: Fountain of Youth
Brian Cambridge and Harry Hall
(both seven years old) having a
splashing time in the fountain in
Coronation Gardens, Dudley, in 1956.

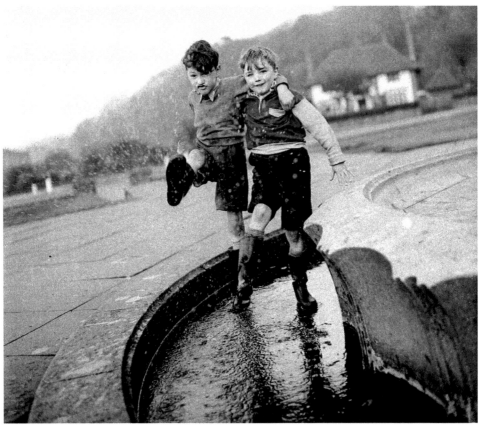

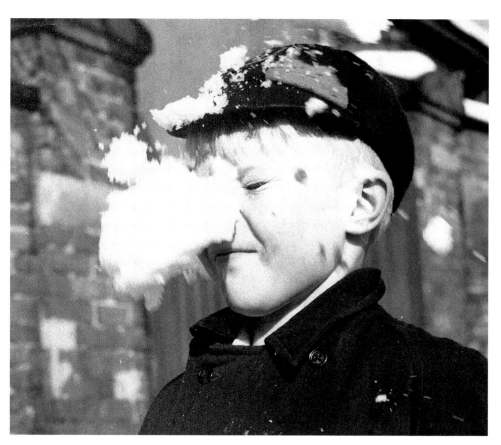

*Above*: Nose for Snow
Kates Hill schoolboy Keith Keeling gets a face full of snow during winter of 1956.

*Right*: Elephant Boy
Four-year-old Adam Southall's dream was to ride on a circus elephant, so he went along to Sir Robert Fossett Circus in Brierley Hill as treat from the ringmaster. But it was all too much for Adam and he became very shy and a little scared and hid his face. Dreams don't always come true.

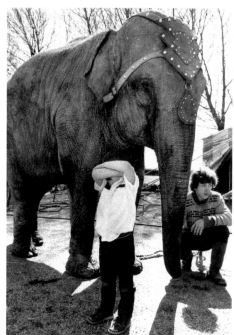

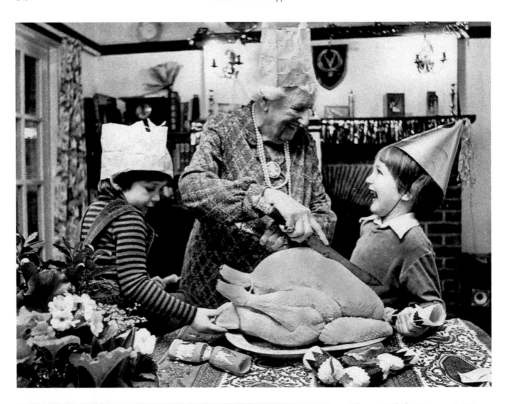

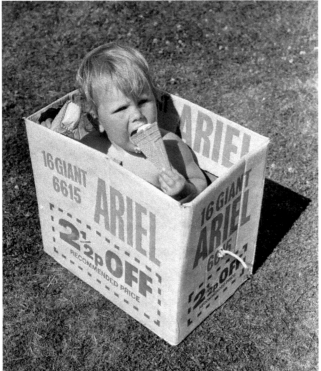

*Above*: While Granny's Not Looking
Great-grandma Mrs May Richards from Kingswinford carving the Christmas turkey in 1980 at the age of 102 while her great-grandson Ross pinches the parson's nose and his brother Philip has a loff.

*Left*: Icebox
This little lass is boxed in and keeping cool with her ice cream.

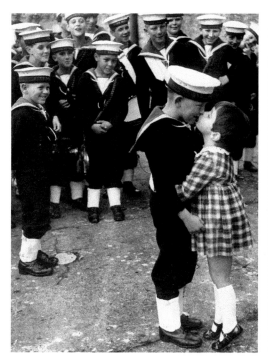

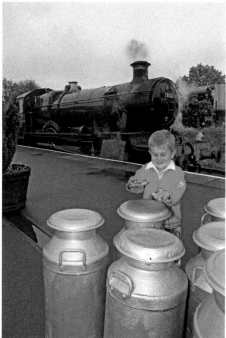

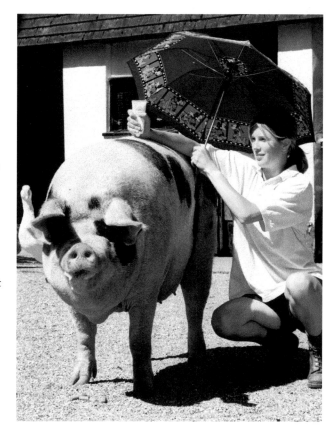

*Above left*: All the Nice Girls
Susan Whitehouse, at the age of seven, finds the appeal of eight-year-old David Priest's uniform too much during a parade of boy seamen.

*Above right*: Whistle Blowin' Eight to the Bar
Young Harry Kerecsenyi thought he would serenade the visitors on some milk churns during his visit to the Severn Valley Railway.

*Left*: Hot Hog
Keeping the pig cool and putting sun cream on his back during a hot spell of weather at the Dudley Zoo Farm.

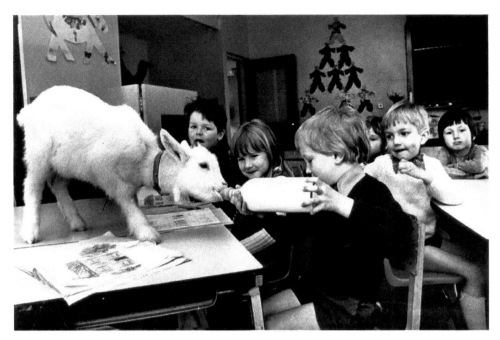

School Kid
Schoolchildren became milk monitors to this pet goat at a Dudley School.

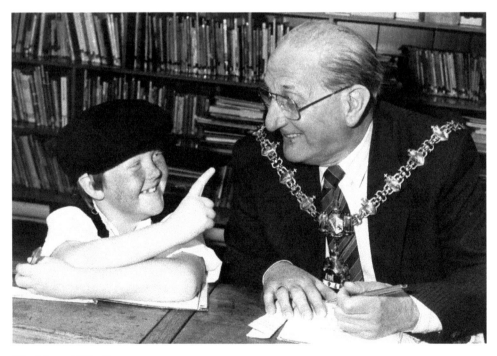

The Mayor of Dudley
Councilor Jim Bradley went back to his old school Brockmoor First School and was caught cheating in class.

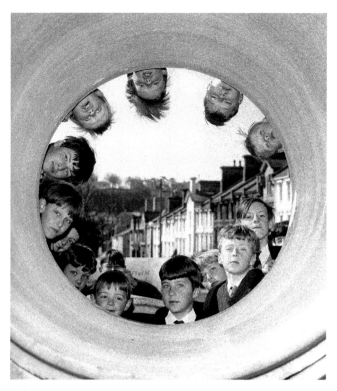

**Pipe Dream**
Boys with an upside view
of the world through sewer
pipes.

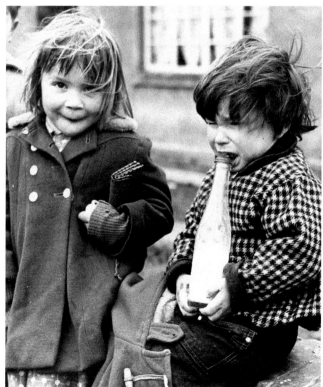

**Don't Bottle It Up**
Two Black Country kids from
Dudley in 1958, the little girl
smiling and clutching her
purse and the boy crying with
a pop bottle of milk.

# LOFF IT OFF

## ... And the Rest

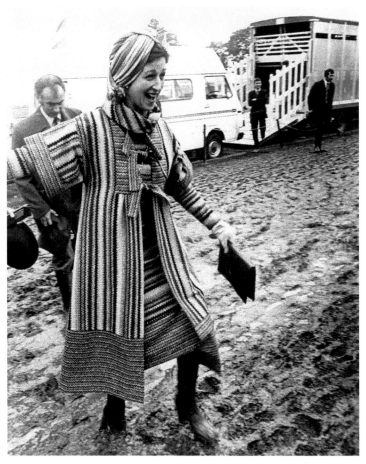

Up to Her Knees in It
Princess Alexandra picking her way through farmyard muck at the
Three Counties Agricultural Show. (This picture won the National
Royal Picture of the Year Award in 1997.)

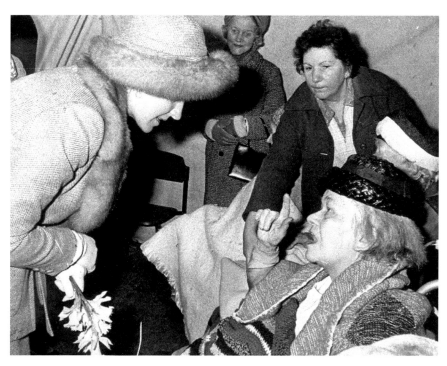

Yo'm Late
When the Duchess of Kent visited an old people's home in Dudley in 1985 she was told off for being late by this Black Country lady.

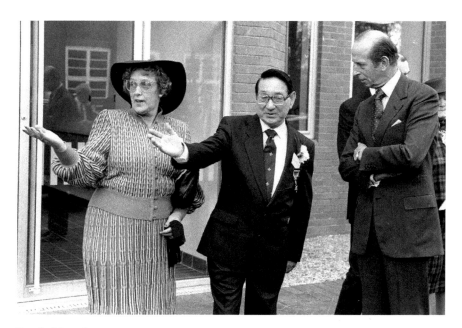

Puzzled Royal
A puzzled Duke of Gloucester is told where to go by Councillor and Mrs Jack Wilson during his visit to Dudley College in 1993.

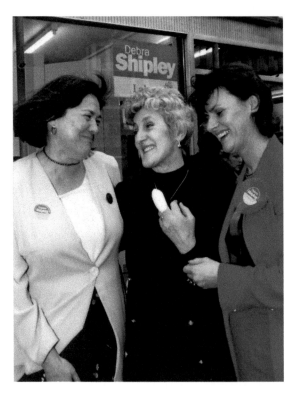

Finger Short
This Labour supporter looks
dangerous as she chats to Labour MP
Clare Short (left) and Debra Shipley
during an election campaign
in Lye.

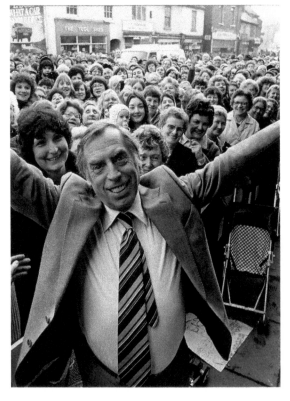

Happy as Larry
The hugely popular Larry Grayson
entertained hundreds of fans when he
opened Old Hill Market Hall in 1980.

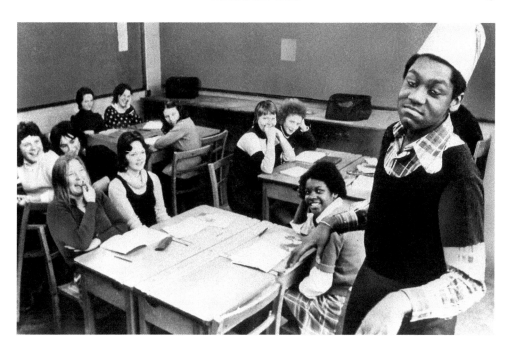

*Above*: Classroom Clown Lenny Henry doing his Tommy Cooper impression to his classmates at the Blue Coat School, Dudley, after he had won the New Faces TV talent show in 1974.

*Right*: Heard This One 'arry Heavyweight boxing champion Frank Bruno played the town crier at his own game during his visit to Halesowen.

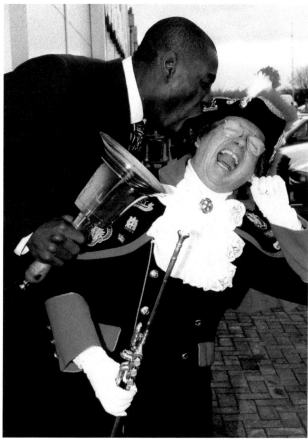

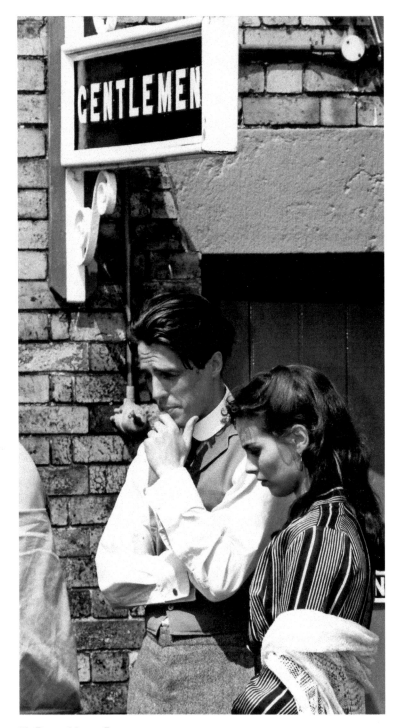

To Pee or Not to Pee
Its decision time for Hugh Grant and Tara Fitzgerald during filming of
*The Englishman Who Went Up a Hill and Came Down a Mountain* on
the Severn Valley Railway in 1995.

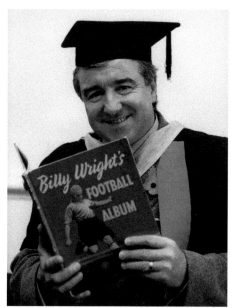

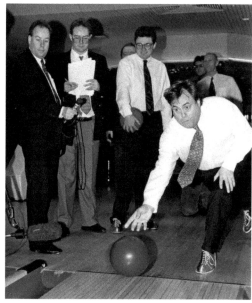

*Above left*: Wright Tips
Former England football coach Terry Venables picking up a few tips from the great Wolves and England player's book *Billy Wright's Football Album*. 'El Tel' was receiving an Honorary Fellowship at Wolverhampton University.

*Above right*: John's Blue Balls
Former Labour Deputy Minister John Prescott was unaware he was playing with Blue Balls at Brierley Hill during an election campaign.

There's Three in This Marriage
Alan Smith with his wife Molly and his stage character Aynuk, which was part of the Black Country double act of Aynuk and Ayli. This picture was taken to celebrate their Golden Wedding.

*Above left*: Our Kid That a Fair
The Black Country comedy pair of Aynuk and Ayli get together for a drink, but as usual Ayli gets short measure.

*Above right*: Black Country Mon
A great Black Country character from Gornal was Sam Jeavons. Dressed in traditional style he cut a fine figure. Sam was well known in the area with his horse and cart selling fruit and veg.

*Left*: Crooked Act
Actors from the Grand Theatre, Wolverhampton, enjoy fooling around outside the famous Crooked House pub in Gornal Wood.

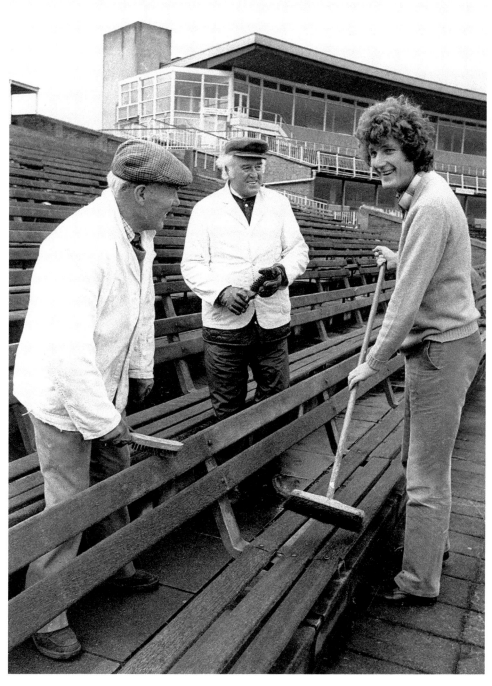

Bowlers End
It was a clean sweep for the great fast bowler Bob Willis when he joined the groundsmen at Warwickshire County Cricket Ground on his retirement in 1984.

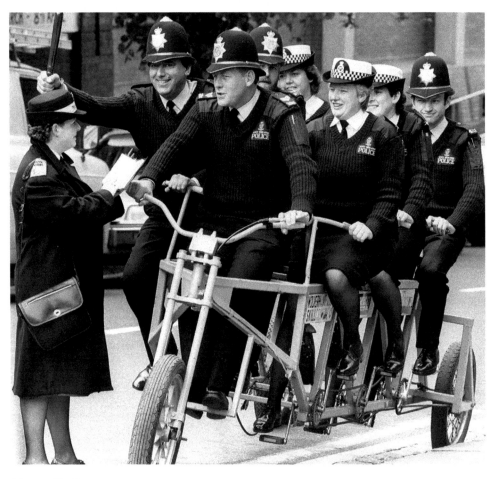

Mounted Police
Traffic Warden Cheryl Ball looked all set to book these police officers when they attempted to park their seven-seater bike outside Dudley Town Hall. They were there to promote the National Cycle Festival at Himley Hall in 1987.

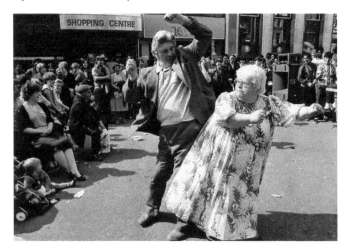

Mighty Mo
Tubby tap dancer Mo the Mighty Atom made an outsized impression on Alf Garderner in Dudley Market Place. Mo was a member of the Roly Poly Dance Group who regularly appeared with Les Dawson on TV.

*Right*: Bald but Bold
The Mayor of Dudley, Councilor Ken Finch, became Spiderman when he met this tarantula during the opening of a new veterinary centre at Coseley in 1986. Vet Graham Parlane was the spider provider.

*Below*: The Naked Truth
A Black Country hen night with male stripper Andy Wade at the Saltwells pub in Quarry in 1975 made international news as male strippers were a rarity at that time. It also went on to win the Midlands News Picture of the Year award and was the inspiration for artist Beryl Cook's *Ladies Night*.

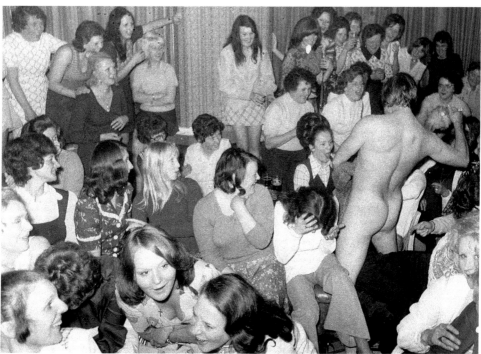

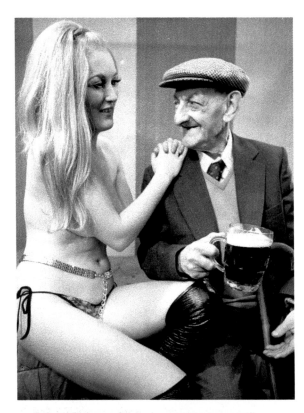

*Left*: Jack and the Stripper
The Saltwells Pub in Quarry Bank would you believe also held a regular lunchtime strip show for OAPs, and pictured is eighty-five-year-old Jack Cartwright enjoying a drink with stripper Anastasia.

*Below*: Rub-a-Dub-Dub There's a Man in the Tub!
Alan Carter gets a rub down during a Friends of the Black Country Museum weekend live-in recreating life as it was in the good old days!

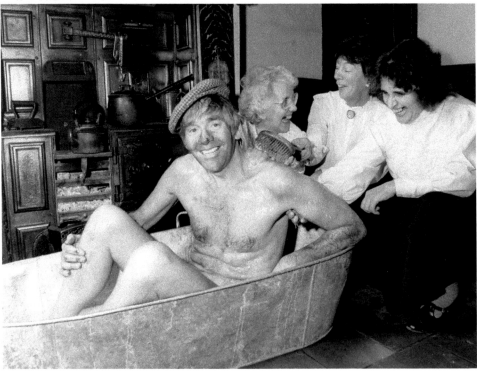

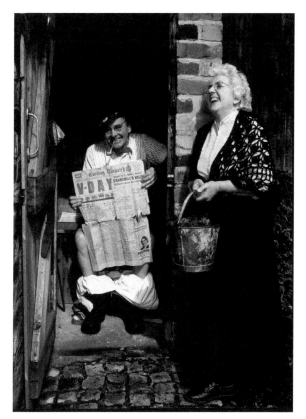

**Crude News**
Alan Carter test runs the Victorian toilet he built himself at the Black Country Living Museum. It took Alan and his wife Jean (pictured) and other Friends of the Museum two years to build this bucket and chucket outside loo.

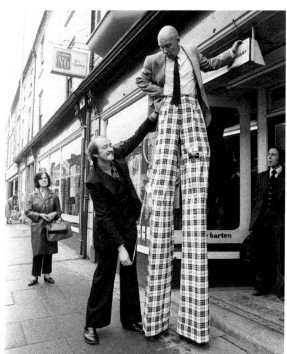

**Tall Wall**
Black Country clown Barrie Wall gets his stilted legs measured for a new pair of trousers in 1978.

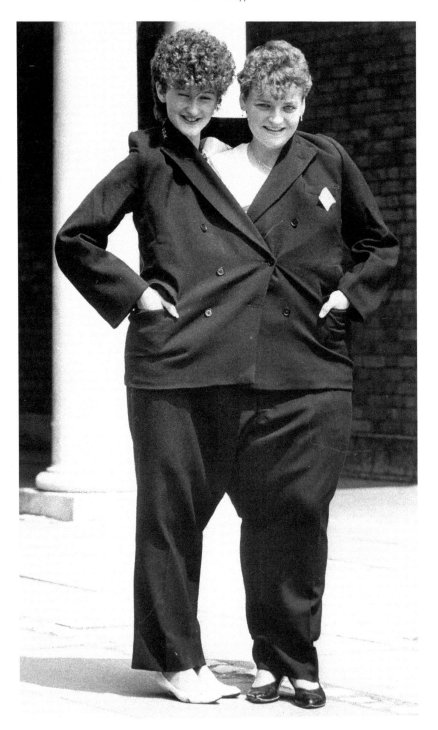

Well Suited
Dudley charity shop had a real big bargain when this outsized suit was donated. Shop girls
Heather Hirons and Jane Sambrooks found the perfect fit ... if both climbed in together. The suit
belonged to a gentleman who was 5 ft 8 in tall, weighed over 20 stone and had a 52-inch waist!

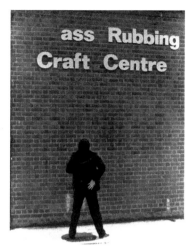 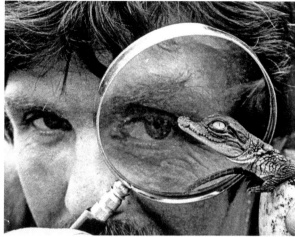

*Above left*: That's the Rub
Missing letter from the Brass Rubbing Centre made folk smile in Bewdley.

*Above right*: Crock Eye
Keeper Graham Chilton comes eye to eye with a newly born crocodile at Dudley Zoo.

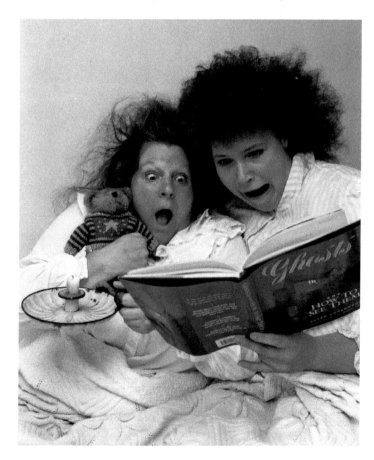

Hairy Scary
These two young ladies got spooked during a ghost hunt at the Bottle and Glass pub at the Black Country Living Museum.

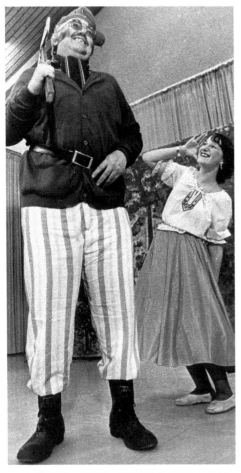

**Giant Dwarf**
The audience at this panto at Buck Pool
School, Wordsley, had to have a vivid
imagination when a 6-foot dwarf came on the
stage in *Snow White and the Seven Dwarfs.*
The problem was they had a shortage of short
men! Pictured is Derek Bradley as 'Doc' and
Susan Bryant as Snow White.

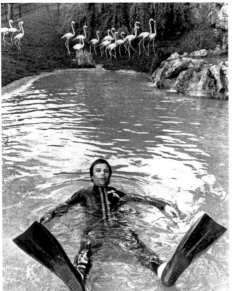

**Flippen 'eck**
Mike Mathias was the general manager of
Dudley Zoo when this picture was taken
in 1978. Mike was getting some practice in
with the pink flamingos for a sponsored fun
run to raise cash to send Dudley's TV's *Its a
Knockout* squad to Italy.

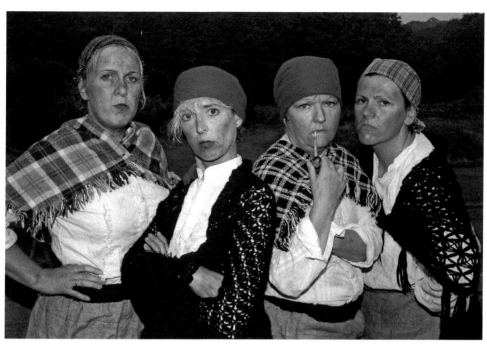

**Fizzogs**
Re-enactment of the striking women chainmakers at the annual Women Chainmakers Festival held at the Black Country Living Museum.

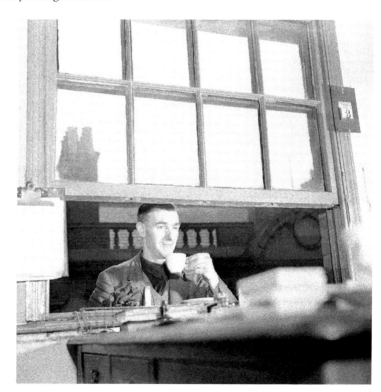

**High Tea**
Window cleaner Charles Summerfield takes his afternoon tea through an office window four storeys high in Priory Street, Dudley, in 1956.

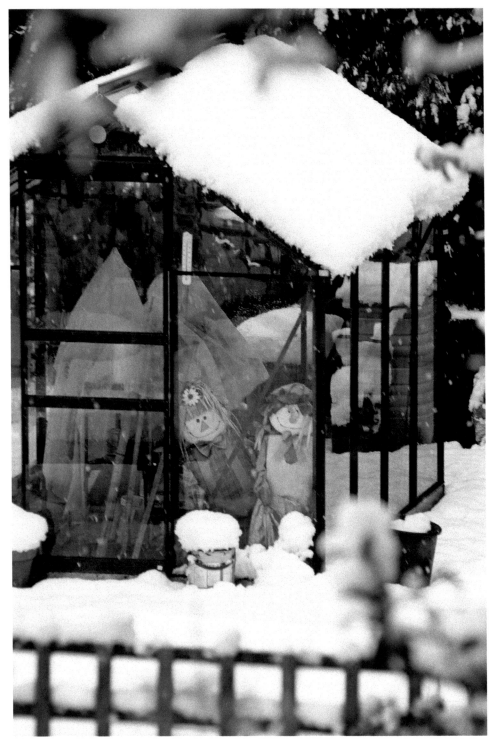

Greenhouse Pals
A couple of garden scarecrows spending winter in a snow-covered greenhouse in Kinver.

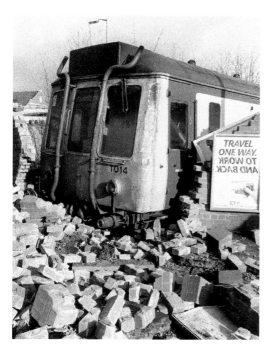

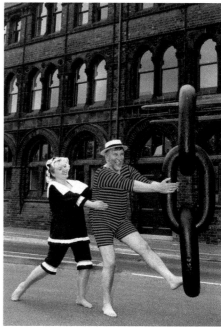

*Above left*: Journey's End
The Stourbridge Dodger lies embedded in the brick wall of Stourbridge Town Station in March 1990. Fortunately no one was hurt (see sign on right of picture).

*Above right*: Chain Gang
Edwardian beach belles Amanda Nash and Bob Dale hang onto the anchor chain made for the ill-fated *Titanic* and now on show at the Black Country Living Museum.

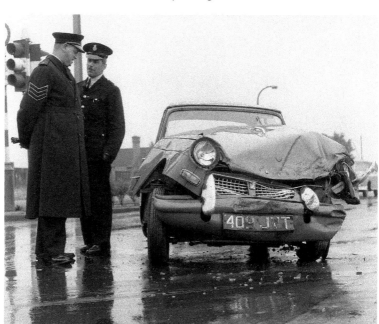

Bent
You should see the chief's bike, sarge! Taken at Coseley in 1960.

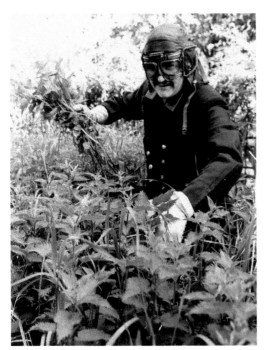

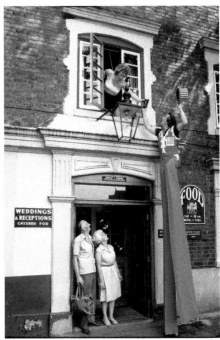

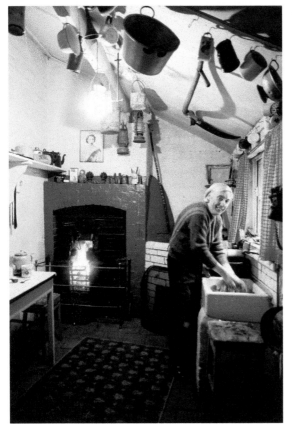

*Above left*: Sting in This Tale
Colm O'Rourk owned a group
of pubs in the Black Country
and was famous for his cow pie
and nettle soup. Colm, known as
'Mad O'Rourk', is pictured in full
protective clothing picking nettles for
his latest batch of soup in 1984.

*Above right*: Tall Order
A circus clown pops up for a drink at
the Saracens Head Hotel in Dudley.

*Left*: Happy in the Past
John Sparry is a happy man living
in the past with all the mod cons of
the 1940s. John is a local historian,
jazz musician, raconteur and runs his
own bookshop in Wall Heath and is
always ready with a yarn, cup of tea
and a little jazz.

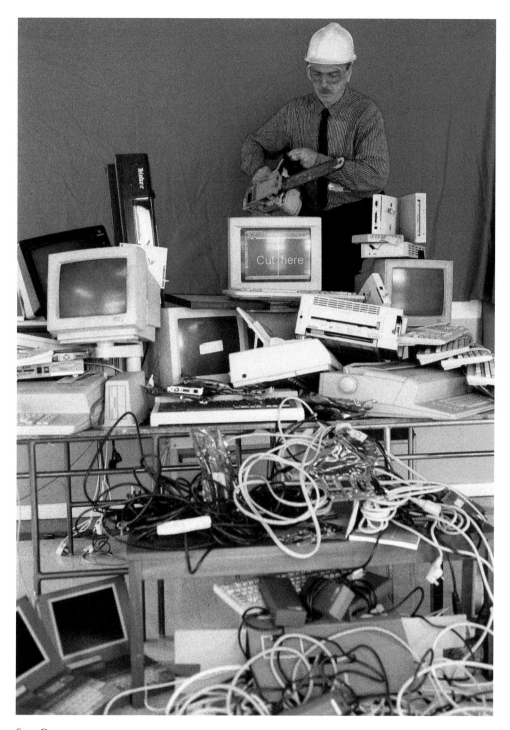

**Saw Computers**
Don't we all feel like this sometimes? Phil Creed takes a chainsaw to his computer, which was part of a Dudley Computer Week where frustrated folk could express their feelings about the machines at an art workshop.

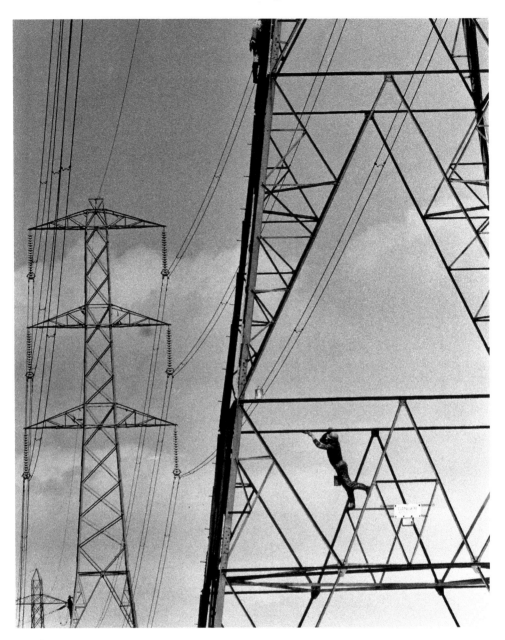

*Above*: Shocking
I spotted this chap painting a pylon at Wall Heath way back in the 1970s with no safety harness and his paint tin hanging from his belt.

*Opposite above left*: Sleeping Tenant
This old chap is having his afternoon nap below a sign for 'homes to let' on Castle Hill, Dudley.

*Opposite above right*: Snow Joke
Eric Langstone shivers in the snow in August ... but all is not what it seems as the BBC were filming a winter scene for their production of *Sophia and Constance* in Dudley in 1987.

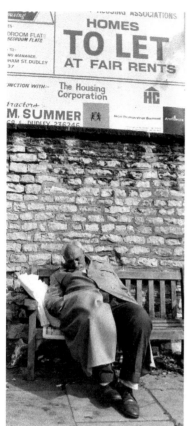

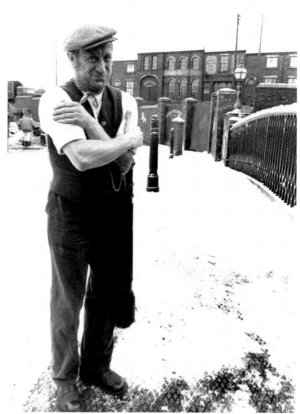

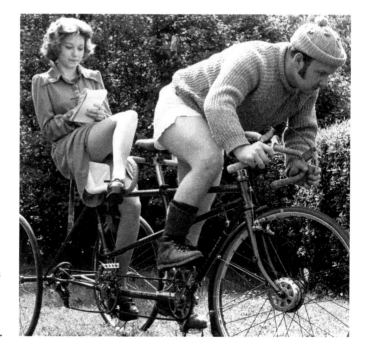

Cycling Notes
Catherine Holden takes
notes from Iain Mills on
a tricycle made for two as
they check the circuit for
a Spring Cycling Festival
which was organised by
Stourbridge Cycling Club.

*Left*: Winter Warmer
Black Country Living Museum guides
keeping warm by the brazier during
a cold spell.

*Below*: Clown Prince
Prince Charles got the Dudley market
stallholders laughing when he made
a visit to the Black Country in 1996.

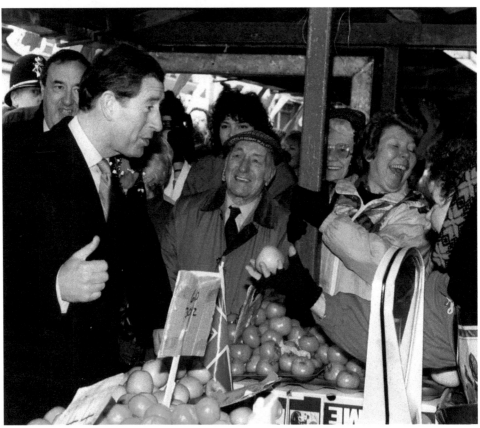

*Right*: Favourite Tot
The Cat Inn at Enville is run by Dan and Aimee Hicks, whose baby son Harvey-Joe had a special beer brewed for him by Enville Brewery on his first birthday with the appropriate name 'The Cats Crawler'.

*Below*: Beer Balladeer
A glass of ale and a sing-song is a tradition in the Black Country pubs, but whoever heard of a licensee singing to his beer! Singing to plants is an old method but the landlord of The Cross pub in Kinver, Chris Vincent, took the idea down his cellar. Chris believed singing helped mellow the ale but customers said it was more like an ale wail!

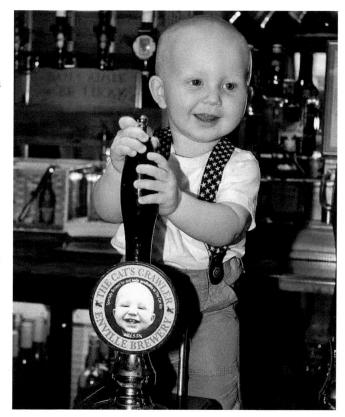

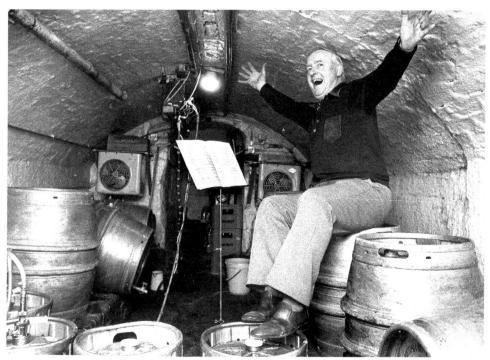

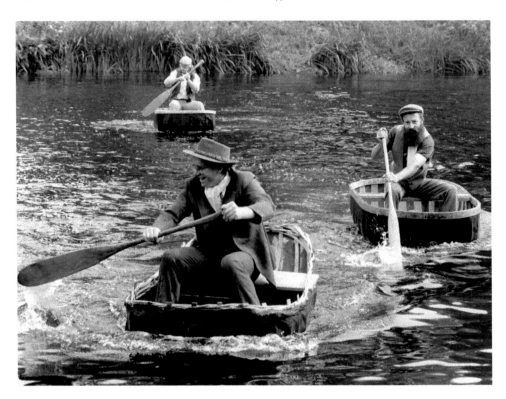

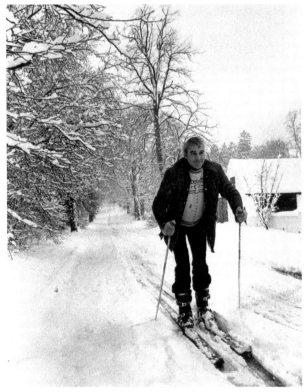

***Above***: Historical Coracle
Having fun coracle racing on the
River Severn during the summer
of 1973.

***Left***: On the Piste
Well not exactly – it's a
snow-covered lane in Kinver
during the hard winter of
1984/85. Alan Smith made the
most of it by skiing around the
village.

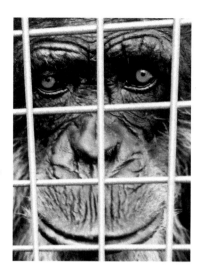

*Right*: Dirty Thoughts
After this birthday picture was taken of Pepe the chimp at Dudley Zoo he hurled a handful of excrement at me, which hit me smack in the face and it went into every crevice of my camera – I smelt that chimp for weeks after.

*Below*: Trumpet Voluntary
Sue Pollard and Felix Bowness entertain members of the Stourport Brass Band during the filming of the BBC's comedy series *Oh! Doctor Beeching* on the Severn Valley Railway in 1997.

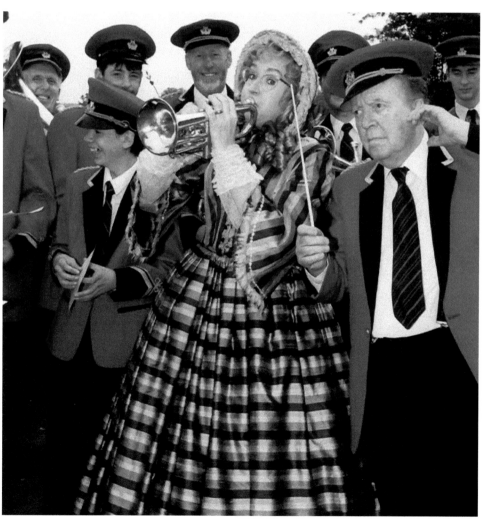

*Left*: Faggits
Television presenters Sue Beardsmore and Nick Owen enjoyed a taste of the Black Country when they tucked into some 'faggits un pays' at Dudley Zoo to raise money for Red Nose Day and all served by the faggot king himself, Richard James.

*Below*: A Grave Move
Grave robbers? No, this was a film set for the production of *Dracula* and Liz Lissimore from Kingswinford helps me with this deadly move.

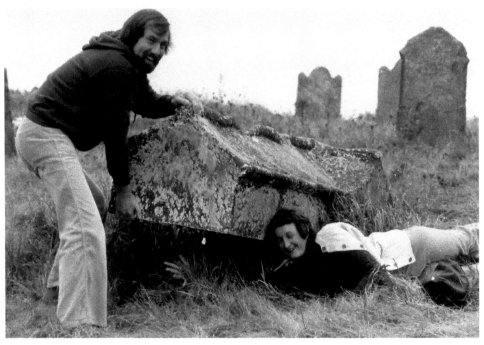

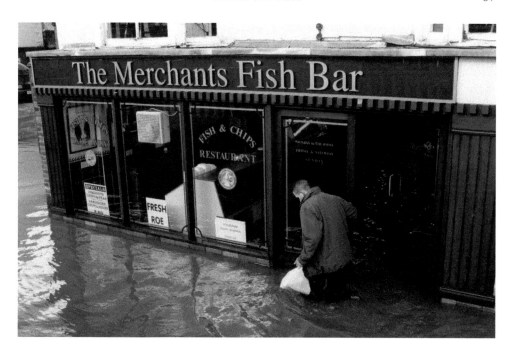

*Above*: Wet Fish and Chips
This chap appears to be getting his feet wet as well as his supper during the floods at Bewdley in 1998.

*Right*: Seems Like a Ice boy
Larry Grayson joins in the celebrations of Helga the polar bear's birthday at Dudley Zoo.

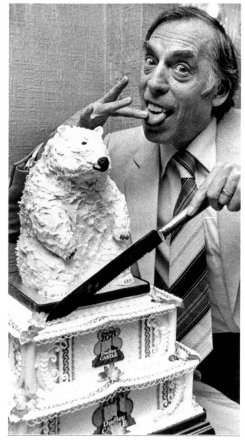

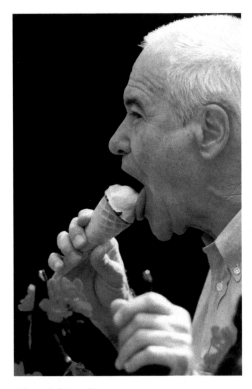 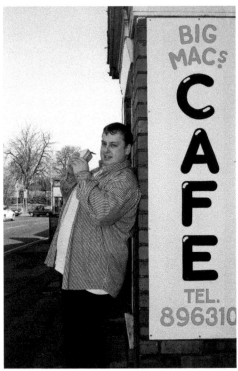

*Above left*: Iced Lemon
Hollywood actor Jack Lemon keeping cool with an ice cream during the summer of 1980.

*Above right*: Burger It!
Darren McDonald was 20 stone and his nickname was Big Mac, so when he opened a cafe at Lye in 1997 he naturally called it Big Mac's. But the burger giant McDonald's were not happy and threatened legal action, but later backed down and so Daren burgered on happily.

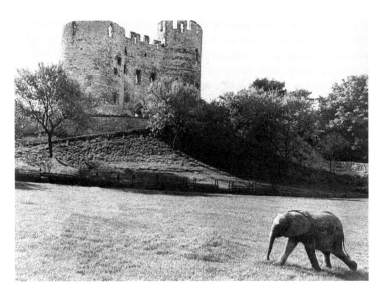

Elephant and Castle
Visitors got a surprise when they spotted Estar the baby elephant taking her daily walk through the castle grounds at Dudley in 1979.

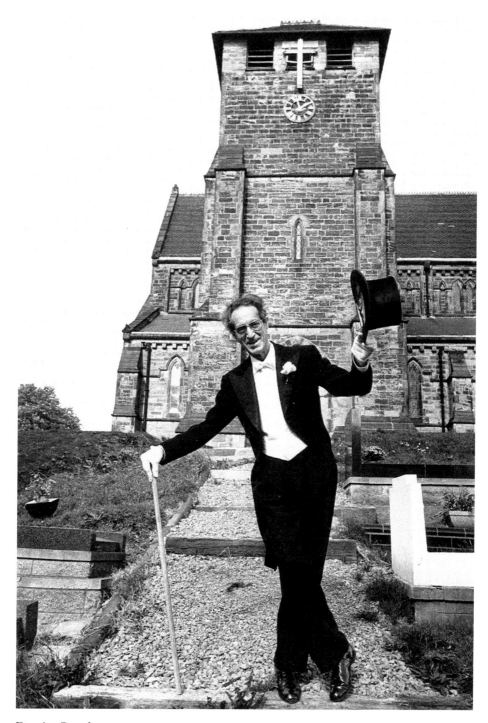

Dancing Preacher
You might have seen Sam Dean quick-stepping his way into the pulpit at St Mark's Church in Pensnett. Besides being a lay preacher Sam was a dancer and member of the Brierley Hill Operatic Society.

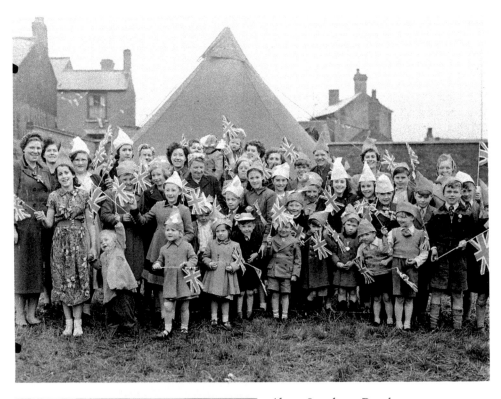

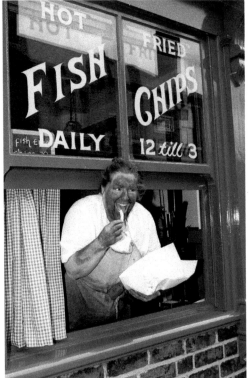

*Above*: Loyalty to Royalty
These happy Dudley mums and children are getting ready with their flags to cheer the Queen when she visited the Black Country in 1957.

*Left*: Fried Food Chain
Chainmaker Sheila Fullard from Bilston not only gave demonstrations in iron craft but was also the fish and chip fryer at the Black Country Living Museum.

What's Up Doc?
In 1984 Tommy Docherty was manager of Wolverhampton Wanderers for under twelve months before being sacked, and this was his reaction to the directors! His famous quote was 'Remember lads, if football directors are too old to do it to their wives they'll do it to their manager.'

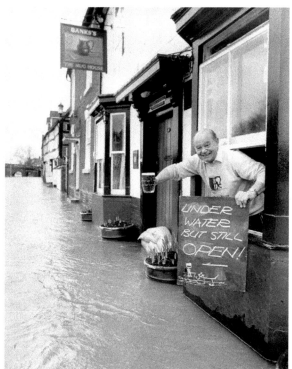

Underwater Drink
Landlord of the Mug House, Bewdley Jimmy Paterson, kept his pub open despite being underwater from the flooding River Severn.

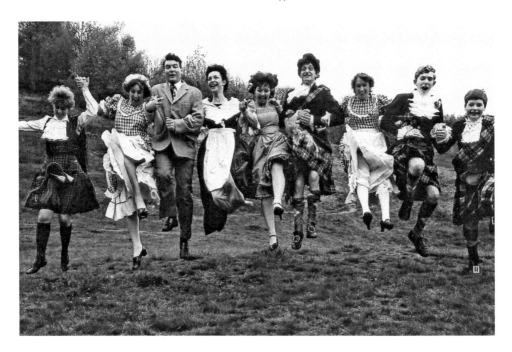

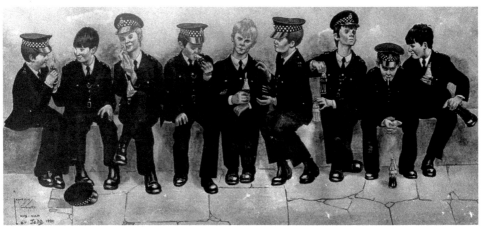

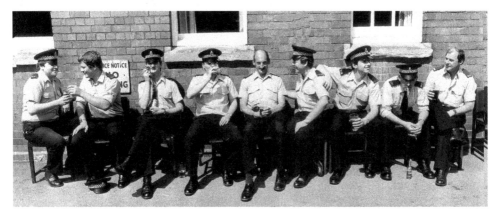

*Opposite above*: Highland Fling
Members of Kinver Operatic Society
fling themselves into their production
of *Brigadoon* on Kinver Edge in 1993.

*Opposite middle and opposite below*:
Nine Half-pints of the Law
Retired police inspector John
Edwards took to painting under
the name of Jed and did this gentle
'mickey take' of young policemen
in 1981. It won the approval of the
local police in the Black Country and
copies were hung on the walls of their
social clubs. Stourbridge police are
pictured paying an off-duty tribute to
the artist posing in similar positions.

*Right*: Kneady Kids
Hungry boys look in through the
bakery window at freshly baked
bread at the Black Country Living
Museum.

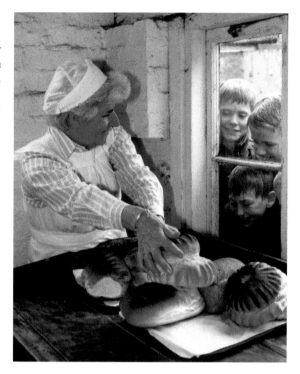

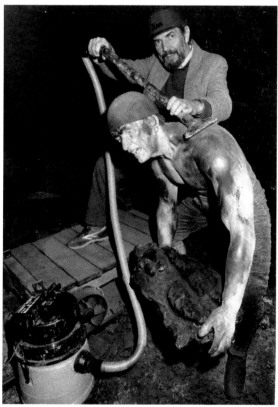

Miner Vacuum
This chap had the job of keeping this
model miner clean deep in the coal
mine at the Black Country Living
Museum.

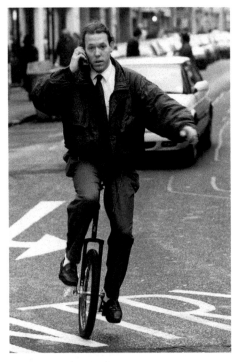

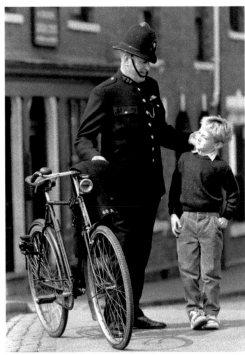

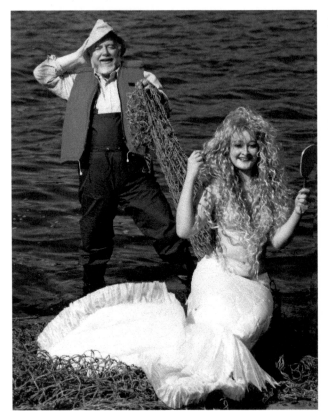

*Above left*: Traffic Dodger
This is one way of getting to
work! Dodging the traffic and
answering the phone is John
Shilvock as he makes his way
down Stourbridge High Street.

*Above right*: Ear Ear
The village bobby gives some
old-fashioned discipline down
at the Black Country Living
Museum.

*Left*: Surprise Catch
Fisherman Roger Lissimore
made waves when he netted
a mermaid from the lake
at Himley Hall. Roger and
his daughter Charlotte, of
Kingswinford, were involved
in the production of *Let
Yourself Go* at the Grand
Theatre Wolverhampton,
Charlotte as a mermaid and
Roger backstage.

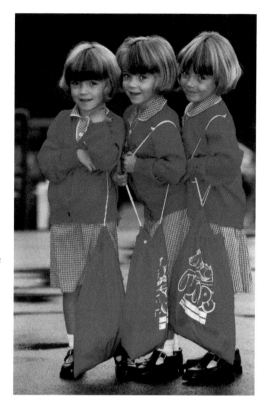

*Right*: Three Little Girls from School Are We
Happy triplets Samatha, Rebecca and Sarah
Pickett's first day at Foley Infants' School,
Kinver, in 1999.

*Below*: Never Too Old
Black Country daredevil Edith Brown went
on an adventure holiday and at the age of
eighty-three took to the 'Death Slide' 100
feet above Lake Windermere – and loved it.

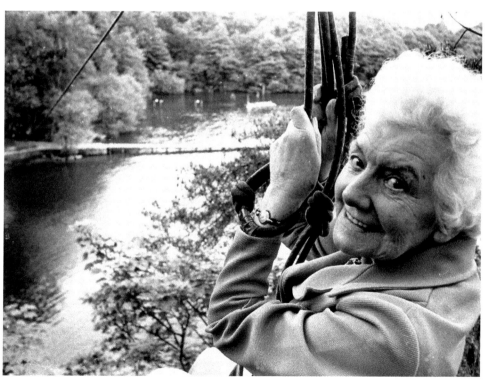

Playing Cars
Just a boy at heart! The great racing driver Stirling Moss playing with toy cars when he
opened a new car showroom in Stourbridge.

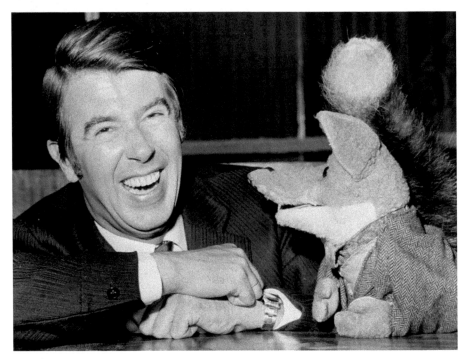

Boom Boom
Lesley Crowther laughing at Basil Brush, but what was he laughing at? The voice of Basil
was not happy he was stuck underneath the table, making some very rude remarks about
press photographers. Sadly after a visit to the Black Country in 1992 Lesley Crowther was
killed in a car crash on the M5. I photographed Lesley many times and he was always a
true professional.

**Getting the Breeze Up**
It was a hot August in 1967 and the heat was getting a little too much for this lady.

**Taxing Problem**
Black Country exile Bernard Shaw went back to the schoolbooks to learn Welsh in a hurry. Councillor Shaw, a tax inspector who came from Sedgley, was elected chairman of Porthmadog Town Council, North Wales, in 1979. The council business was conducted in Welsh and they refused to use English, so Bernard had a translator for the council meetings while he was getting his tongue round the language. This made a great story, appearing in the national press and on TV.

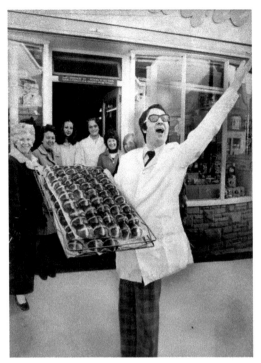

*Left*: Serenade for Bun Buyers
Kinver shopkeeper Barrymore Lee was
a man who believed in music while you
work. In the village he was known as the
singing grocer and had won many top
prizes in music and drama. No one was
surprised when he broke into song while
carving the cheese or serving hot cross
buns. He could render opera while stacking
the beans or polish off a brisk Gilbert and
Sullivan solo when slicing the bacon.

*Below*: Stumped
Michael Rowley is relegated to sleep in the
pavilion at Stourbridge Cricket Club after
his wife, Mildred, claimed in a divorce
court that her husband spent more time
at the cricket club than at home. Michael
missed only one match in twenty-one years.

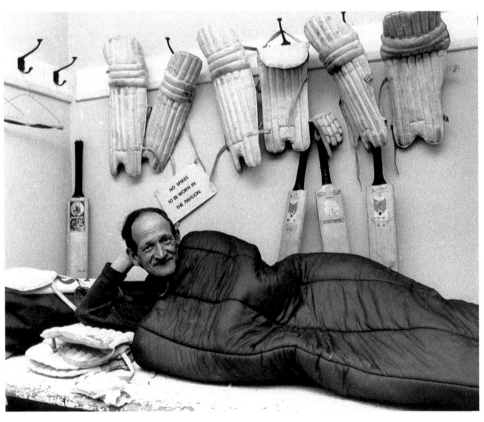

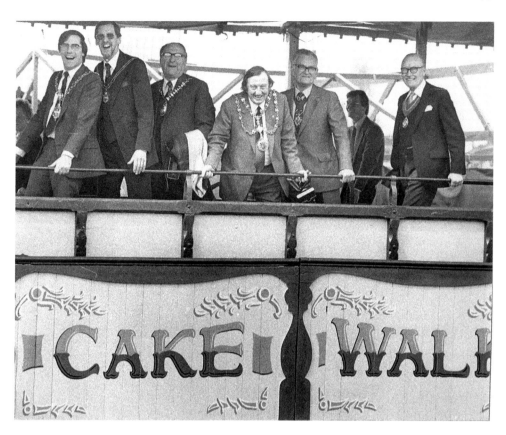

*Above*: Keeping Upright
Black Country civic leaders try
to keep upright on the Cake
Walk at the Black Country
Living Museum.

*Right*: Slip-sliding Away
Granny looking after baby in the
Galleon Milk Bar, Dudley,
in 1958.

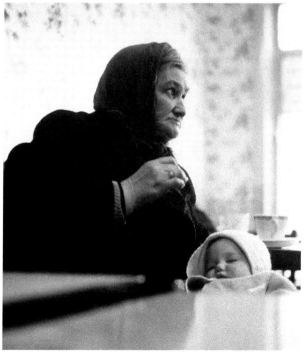

*Above*: Caravan for the Little People
Ken Jackson from Kidderminster built
this different sort of Wendy house for his
grandchildren.

*Left*: This Kid Takes the Biscuit
Neil Kinnock chats to a little girl who is more
interested in her Hobnob than hobnobbing with
politicians during his visit to Dudley in 1992.

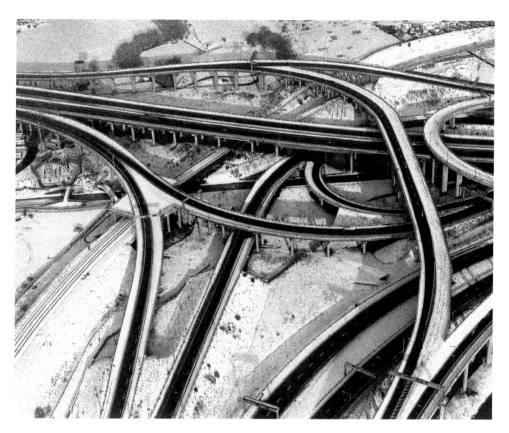

*Above*: Frozen Spaghetti
This would please any driver! Rush hour at Spaghetti Junction and no traffic. The reason being in January 1979, 50 miles of the M6 had been closed and the M42 shut. The picture was taken from a helicopter.

*Right*: We Look Down on Her
Workers looked down and voiced their opinions of the Iron Lady when Maggie Thatcher visited Coseley in 1987.

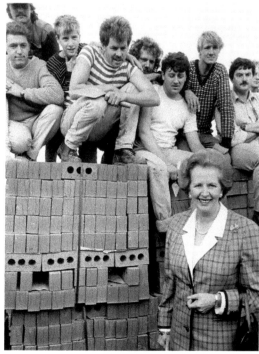

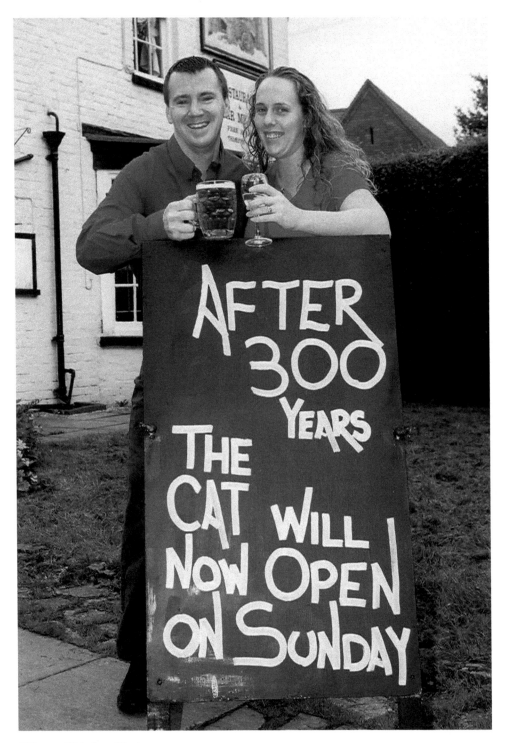

**300-year Wait for a Pint!**
This made the locals smile when after 300 years The Cat at Enville was opened on Sunday. Licensee Guy Ayres and his wife Michelle celebrate.

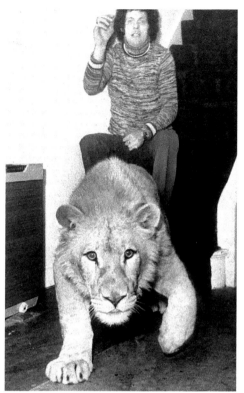

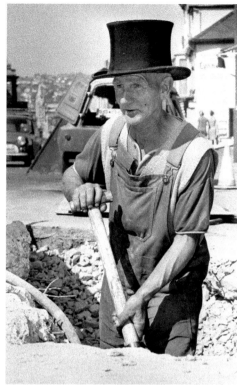

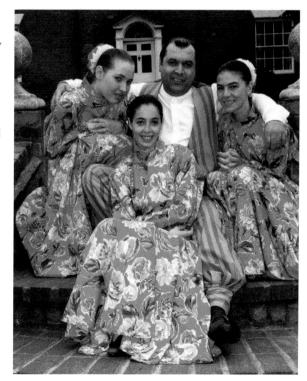

*Above left*: Lion Guard
Laddo the Lion was kept at the Cradley Heath home of Lewis Foley with his wife and three children. When I went to photograph Laddo in 1970 I think it must have been lunchtime!

*Above right*: Gentlemen of the Road
Black Country holidaymakers in Torquay during the 1960s were surprised to see a top-hatted road worker and he became a favourite for their holiday snaps.

*Right*: Treble and Strife
Kidderminster restaurant boss with his three lookalike wives – Sarah, Stefania and Cinzia – pictured in 1995. The wealthy Medi Siadatan insisted 'My wives all get on very well and are not jealous of each other.' Two of his wives worked in his restaurant and one looked after his four children.

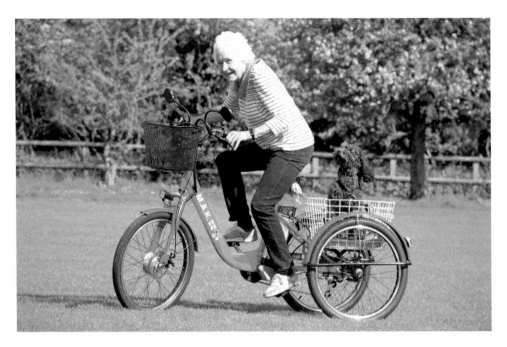

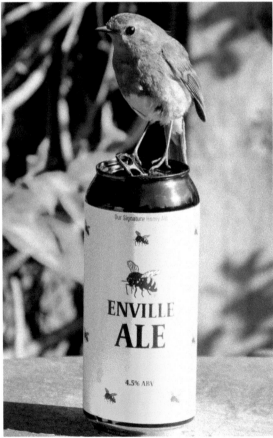

*Above*: Barking-good Ride
Eco-friendy Kath Tunnicliffe with her electric tricycle riding around Kinver with her cockapoo Molly. Kath, who is a village litter-picker and charity worker, said 'Molly is in her element and always looks forward to riding pillion.'

*Left*: Ale-ing Robin
Even the birds are attracted to this local honey brew, Enville Ale.

A Brush with the Mayor
Dudley's new mayor in 1982,
Councillor Bob Griffiths, launched
a clean-up campaign and took to
the streets with brush in hand in
his mayoral robes to the disdain of
council officials.

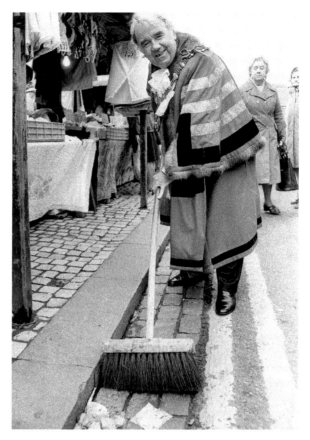

Frog Eye
Tree frogs were found in the Asda
store at Brierley Hill in 1995 and it
was thought they came from South
America in the packaging.

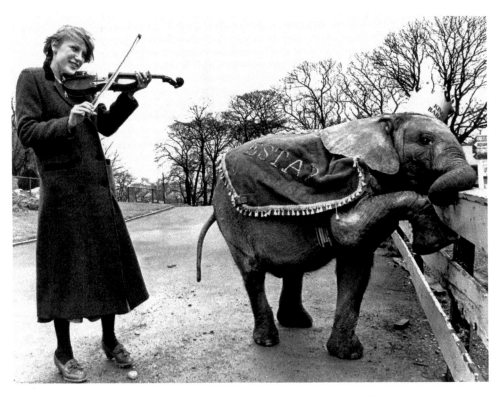

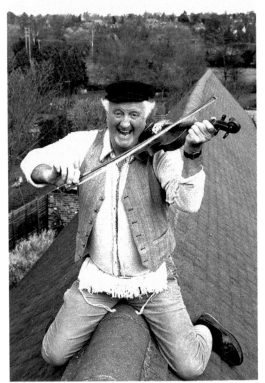

*Above*: On the Fiddle
Violin music drove Estar the elephant
up the fence at Dudley Zoo when Julia
Gordon from Stourbridge serenaded her
as a prelude to an orchestral concert of
children's classics at Dudley Town Hall.

*Left*: Getting a High Note
Ken Pearson took to the roof of the
Kinfayre restaurant, Kinver, to get in the
mood for his lead roll of Tevye in the
musical *Fiddler on the Roof*.

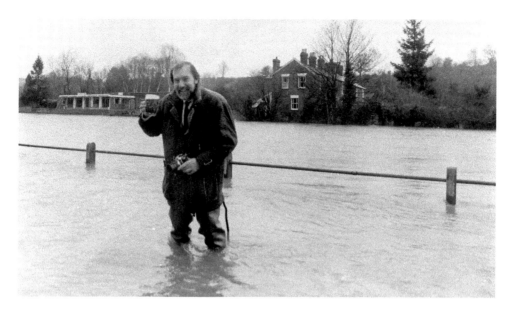

*Above*: River Brew
Having a pint in the flooding
River Severn at Bewdley courtesy
of Jimmy Paterson, landlord of
the Mug House Inn, who handed
it to me through the pub window
when I was taking flood pictures.

*Right*: Golden Moldies
Jack Day had been entertaining
customers with a song while
he delivered their daily loaf
for thirty-three years in the
mid-1970s. Although his bread
was fresh his melodies were
getting a little crusty, but he kept
the housewives smiling while
singing such songs as 'Shortnin'
Bread', 'Bread of Heaven', 'If
I Knew You Were Comin' I'd
Have Baked a Cake', 'Mouldy
Old Dough' and Meat Loaf's
greatest hits … oh dear I think I'll
stop now.

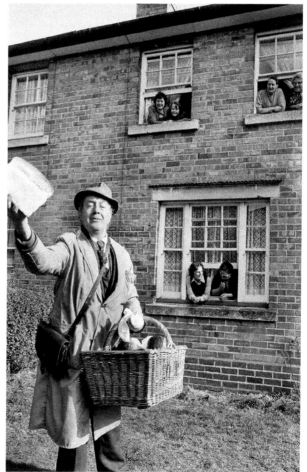

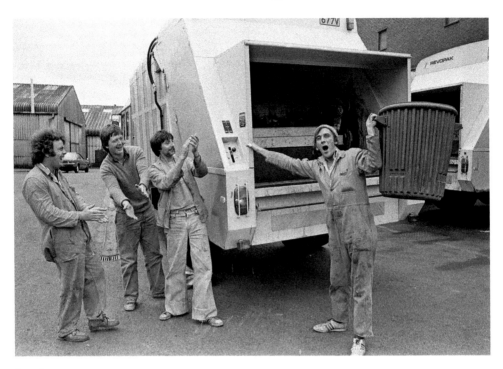

Stardust

After years of singing in local choirs and as a pub and club artist, dustman Johnny Hayman was about to release a record when this picture was taken in 1980. Johnny, whose real name was John Hillman, came from Coseley and is pictured serenading his colleagues while working on his round in Dudley. But what happened to the record? Did it end up on the scrapheap, or is it gathering dust somewhere waiting to be recycled?

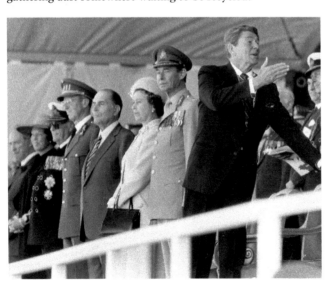

Eyes Front Mr President

In 1984 I travelled to Normandy with some Black Country veterans for the 40th anniversary of the D-Day landings, where all the European heads of state were attending, as were the Queen and President Reagan. While the ceremony was taking place on Omaha Beach, all eyes were on the march past except one: President Reagan had spotted someone he knew in the crowd and turned and chatted; the unexpected made this amusing picture.

# SNAPPING FUNNY SIGNS

Its not everyone's idea of a night out, but at least its a little different. It seems during the 1960s visitors to Dudley Hippodrome could watch the Merry Widow wrestling and not just once in a while but every Sunday night at 7.30. This is one of many amusing signs I have spotted and captured on camera over the years.

Another favourite of mine is the sign outside the Dolphin Inn at Kingston in South Devon, which appears to invite motorists to drive their cars straight through the sixteenth-century inn. Providing they do it slowly, of course. Also in Devon is the sign which appears to suggest that you might want to pop into the gents for a cuppa.

Then there is freshly dug locals for £345 outside a grocery store selling potatoes with the decimal point missing – thankfully not near a cemetery at Netherton in the Black Country. Down in Cornwall the owner of the Banjo Cafe in Looe boasts that if there was such a thing as a 'Bad Food Guide', they would be in it. Back in Devon again, 'Rocky', who owned the beach cafe in South Milton, used to write a philosophical message on the blackboard outside his premises every day.

One that always raises a smile is the sign at Attingham Park cafe courtyard covered in snow with a sign reminding people that ice creams were on sale. Then there is a young girl bemused by a sign directing visitors to a beach in the sky in North Devon.

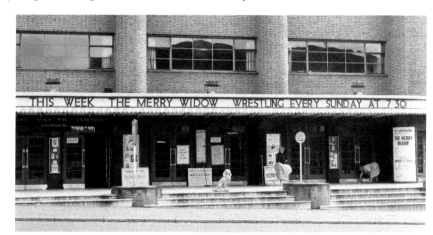

The
Merry
Widow
Wrestling.

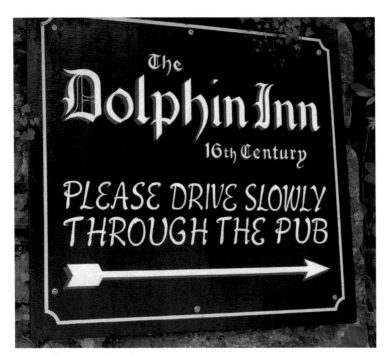

Drive slowly
through the
Dolphin Inn,
Kingston, Devon.

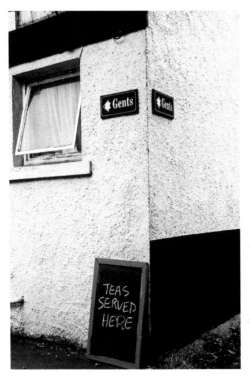

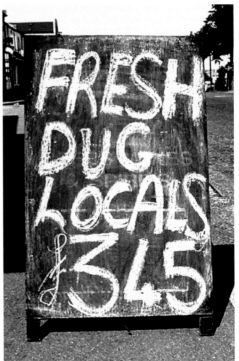

*Above left*: Tea for gents, Devon.

*Above right*: Fresh-dug locals, Black Country.

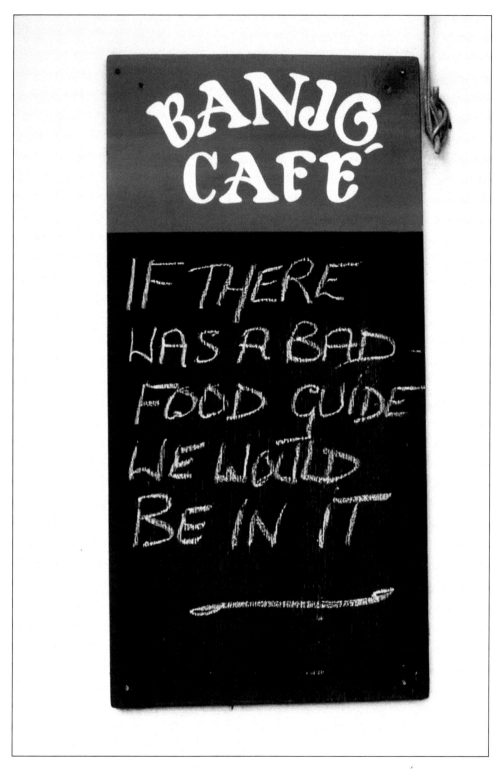

Bad food, Banjo Café, Looe, Cornwall.

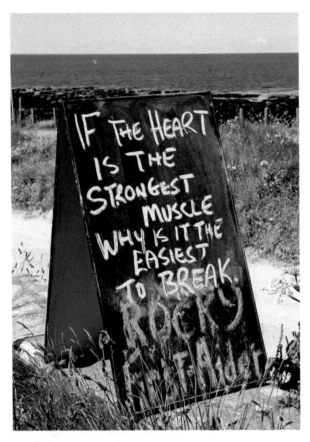

*Left*: Philosophical message, South Milton, Devon.

*Below*: To cold for ice cream, Attingham Park, Shropshire.

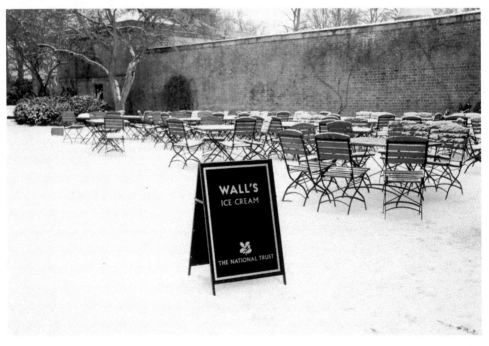

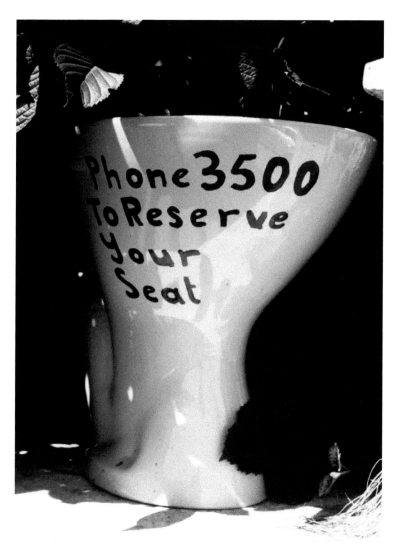

*Right*: Reserve
your seat at
this restaurant,
Borth-y-Gest,
North Wales.

*Below*: Torture
Chamber gift shop
at Warwick Castle.

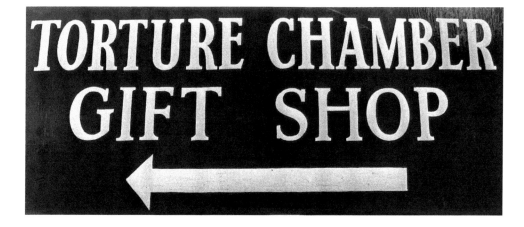

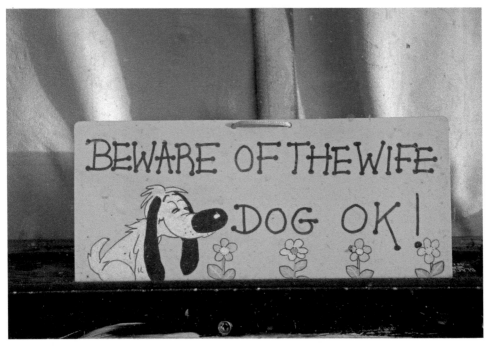

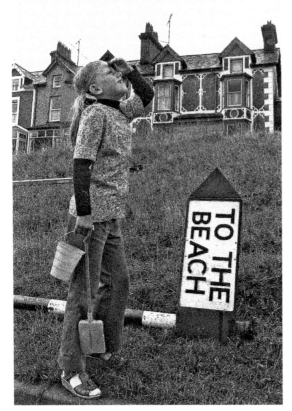

*Above*: Boat sign on the Staffordshire and Worcestershire Canal.

*Left*: Beach in the sky, North Wales.

*Right*: Spotted outside a pub in Ludlow.

*Below*: Blackbird nesting at Great Mills Garden Center, Brierley Hill.

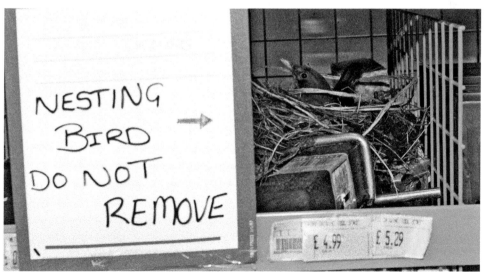

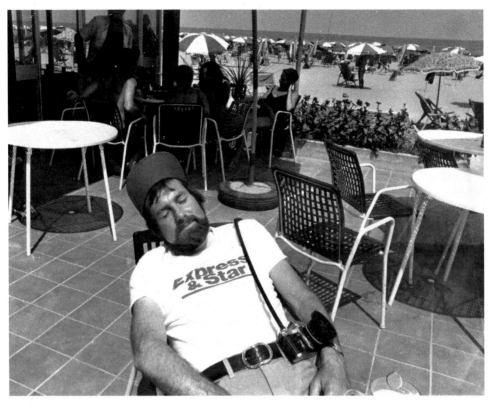

**Knock-out**
That's all folks … taking all these pictures makes a chap tired. This picture was taken in Italy when Dudley were taking part in the TV show *It's a Knockout*.

# ACKNOWLEDGEMENTS

Midlands News Association, Mirrorpix. Also, a special thanks to Mark Andrews, Senior Feature Writer, Express & Star, for his invaluable help with picture research and dates. Also to Mary for her constant help and patience.